CHINESE CERAMICS
FROM
JAPANESE
COLLECTIONS

Asia House Gallery, New York

Seattle Art Museum

Kimbell Art Museum, Fort Worth

Asian Art Museum of San Francisco,
The Avery Brundage Collection

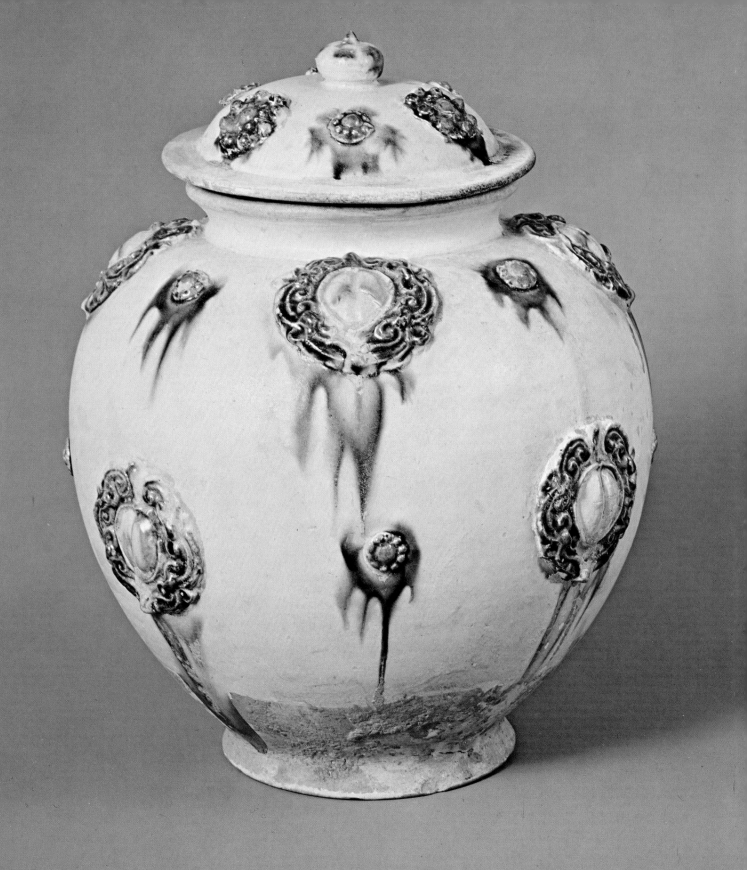

CHINESE CERAMICS FROM JAPANESE COLLECTIONS

T'ANG THROUGH MING DYNASTIES

Seizo Hayashiya and Henry Trubner

in collaboration with

Gakuji Hasebe, Yoshiaki Yabe, Hiroko Nishida,

William J. Rathbun, and Catherine A. Kaputa

AN EXHIBITION OF CHINESE CERAMICS FROM PUBLIC AND PRIVATE COLLECTIONS

IN JAPAN ORGANIZED UNDER THE JOINT SPONSORSHIP OF THE AGENCY

FOR CULTURAL AFFAIRS OF THE JAPANESE GOVERNMENT

AND THE PARTICIPATING INSTITUTIONS IN THE UNITED STATES

The Asia Society
In Association with John Weatherhill, Inc.

This project is supported by the
Agency for Cultural Affairs (*Bunka-chō*), Tokyo,
and by grants from the
National Endowment for the Arts in Washington, D. C., a Federal agency;
the Asia Foundation, Tokyo and San Francisco;
the JDR 3rd Fund; and the Andrew W. Mellon Foundation.

An Asia House Gallery Publication
© The Asia Society, Inc., 1977.
Printed in the United States of America

Library of Congress Cataloguing in Publication Data
Main entry under title:
Chinese ceramics from Japanese collections.
 "An exhibition of Chinese ceramics from public and pri-
vate collections in Japan organized under the joint sponsor-
ship of the Agency for Cultural Affairs of the Japanese
Government and the participating institutions in the United
States."
 Held at Asia House Gallery, New York, and at three other mu-
seums.
 Bibliography: p. 133
 1. Pottery, Chinese—Exhibitions. 2. Pottery—Collectors
and collecting—Japan—Exhibitions. 3. Porcelain, Chinese—
Exhibitions. 4. Porcelain—Collectors and collecting—Japan
—Exhibitions. I. Hayashiya, Seizo. II. Japan. Bunkachō.
III. Asia House Gallery, New York.
NK 4165.C4796 738'.0951'074013 77-1654
ISBN 0-87848-049-8

FRONTISPIECE: NO. 2. Jar and cover; T'ang dynasty, 8th century; three-color ware; H. 9⅝ in. (24.5 cm.)

Contents

Preface

I wish to express my great delight that the exhibition of Chinese ceramics from Japanese collections is being brought to the United States and will be shown at Asia House Gallery, the Seattle Art Museum, the Kimbell Art Museum, and the Asian Art Museum of San Francisco.

This exhibition has been developed around Chinese ceramics which were transported to Japan between the eighth and the seventeenth centuries. Included are wares which became a part of the daily lives of the Japanese.

In Japan the influence of Chinese ceramics has been strong since the introduction of Buddhism in the sixth century and large quantities of ceramics were imported in both the late Nara and the Heian periods (eighth-twelfth centuries) as part of the commercial trade with the continent. These were greatly admired by members of the nobility. During the Kamakura and Muromachi periods (thirteenth-sixteenth centuries), the interest of the military class in Zen Buddhism and the aesthetics of the tea ceremony helped to develop the earlier admiration of Chinese ceramic wares into a system of appreciation that was uniquely Japanese. As a result, great numbers of fine objects, such as superb tea bowls and flower vases, were collected as part of the "taste for things Chinese" and loved and treasured from generation to generation as *meibutsu* (special articles). Among the *meibutsu* are many rare objects that have survived only in Japan. More recently, from the seventeenth century on, the influence of Chinese ceramics has stimulated the production of new ceramics in every corner of Japan, and thus reached the lives of the common people as well. In this way, Asian ceramics handed down in Japan have become a unique part of Japanese life. Even though they were objects from abroad they inevitably merged with our own cultural resources and have become part of our heritage.

This exhibition has been arranged in response to the enthusiastic request of the Seattle Art Museum as well as of the other museums for another exhibition of ceramics to follow "Ceramic Art of Japan," which was presented in the United States during 1972 and 1973 in Seattle, Kansas City, New York, and Los Angeles. It has been conceived and executed in accordance with the growing desire for a program of increased cultural exchange among nations. I will be pleased if, through its presentation, the superb artistic nature of Asian ceramics and their broad influence can be better understood.

In conclusion I would like to express my gratitude not only to the Seattle Art Museum and its professional staff, but also to the other participating museums for their unstinting efforts and devotion which have made possible the opening of the present exhibition. I would also like to express the sincere hope that the exhibition will play a significant role in assuring the continued success of the current Japan-U.S. cultural exchange program.

Hisashi Yasujima
Commissioner, Agency for Cultural Affairs, Tokyo

Foreword

The idea behind this exhibition is a most intriguing one which has often occupied scholars of Asian art and culture. The relationship between China and Japan has been exceedingly complex and varied. Although there were times when Japan sought isolation and actively endeavored to be free of the influence of her continental neighbor, Chinese philosophy, learning, and art have played an important role in Japanese cultural life from the time the Buddhist religion was first introduced to Japan in the sixth century A.D.

It is a specific part of this relationship that we seek to illuminate here. Although the focus is on ceramics, specifically the superb quality and historical importance of Chinese ceramics that exist in collections in Japan, it should be remembered that there is a tangible *Japanese* sense which underlies every facet of the exhibition. The absence of certain types of wares which one would expect to find in Western collections should come as no surprise. Almost all the pieces assembled here were imported to Japan between the eighth and the seventeenth centuries, and many were made on special order for Japanese customers. Thus the exhibition represents not only a survey of outstanding examples of Chinese ceramics, but also an essay on Japanese taste. Of particular interest is the place which Chinese ceramics held in the Japanese tea ceremony. And where else in the world but in Japan would one discover a history such as that which accompanies the celadon tea bowl that once belonged to the Shogun Yoshimasa? Lastly, it is revealing to set these wares in the context of the history of Japanese ceramics and discover where China did and did not exert its influence.

The fact that Asia House Gallery and the Seattle Art Museum are cosponsors of this exhibition emphasizes a long and successful collaboration between the two organizations. Since 1960, the year of its founding, Asia House has been able to share a number of exhibitions with Seattle and this is, in fact, the eighth to be shown in both institutions. In addition, the Seattle Art Museum and Asia House have been most fortunate to be able to call upon the experience and connoisseurship of Henry Trubner. Mr. Trubner, the organizer of this exhibition, has been Curator of the Department of Asian Art at the Seattle Art Museum since 1968 and last year became the Museum's Associate Director. He has served on the Gallery Advisory Committee for Asia House since 1971 and has also organized two other exhibitions shown at Asia House: *Arts of the Han Dynasty* in 1961 (when he was Curator of the Far Eastern Department of the Royal Ontario Museum) and *Ceramic Art of Japan* in 1972.

As Mr. Trubner points out in his own acknowledgments, it was during the organization of the latter exhibition that the present project was first discussed. Happily, many of the same individuals, agencies, and institutions have been involved here and the same high degree of cooperation, support, and interest has been shown both in Japan and the United States.

Mr. Trubner has made specific acknowledgments to the many individuals who worked with him to bring

this effort to its successful conclusion and we add our deep thanks to his. We wish also to emphasize the crucial financial aid received from the following sources: the National Endowment for the Arts, which has made two separate grants to the Seattle Art Museum and Asia House Gallery respectively to defray organization costs and catalogue expenses; the Asia Foundation and the JDR 3rd Fund, which made specialist and curatorial travel possible; and the Andrew W. Mellon Foundation, which has provided support for the catalogue. Lastly and of equal importance, full insurance coverage, provided through the Arts and Artifacts Indemnity Act, was granted to this exhibition by the Federal Council on the Arts and Humanities.

International exhibitions of this nature require experience, funding, and cooperation from individuals, governments, foundations, and agencies. This exhibition and the publication and activities which accompany it are tangible expressions of our gratitude for their assistance and support.

<div style="text-align:center">

Allen Wardwell Willis F. Woods
Director, Asia House Gallery *Director, Seattle Art Museum*

</div>

Acknowledgments

This undertaking has grown out of an earlier, highly successful collaboration between Japanese and American institutions. In 1972 the Seattle Art Museum, with the generous support of the Agency for Cultural Affairs of the Japanese Government, organized the exhibition, "Ceramic Art of Japan." This was the first major exhibition of Japanese ceramics drawn entirely from museums and private collections in Japan to be shown in the West. Now, five years later, support from the Agency for Cultural Affairs has made it possible to bring a second group of ceramic treasures from Japanese collections to the United States, this time for an exhibition devoted exclusively to the ceramic wares of China. Focusing on excavated pieces and ceramics transmitted over the centuries from generation to generation, "Chinese Ceramics from Japanese Collections" explores aspects of China's ceramic tradition which have shaped both the Japanese taste in ceramics and the development of ceramic art in Japan. The exhibition will mark the first time this distinctive group of wares has been shown outside of Japan.

"Chinese Ceramics from Japanese Collections" is jointly sponsored by the Agency for Cultural Affairs (*Bunka-chō*) and the participating American museums, with Asia House Gallery and the Seattle Art Museum sharing the organizational responsibilities on the American side. Working in close cooperation with officials of the Agency for Cultural Affairs and the Tokyo National Museum, the writer undertook all negotiations with the Japanese side and actively participated in the selection of the objects, laying the groundwork for the exhibition during the course of two trips to Japan, in the fall of 1974 and the spring of 1976. Assisted by the staff of the Seattle Art Museum he has been responsible for carrying out all administrative and technical details pertaining to the organization and circulation of the exhibition. For its part, Asia House Gallery has assumed all responsibility for designing, editing, and publishing this catalogue.

The exhibition would not have been possible without the help of numerous organizations and individuals both in Japan and in the United States. First and foremost, our gratitude is extended to the many lenders in Japan, without whose generosity and willingness to participate in this exhibition the project would have failed at the outset.

The participating museums are greatly indebted to the Agency for Cultural Affairs for the invaluable assistance it has given us ever since the exhibition was first proposed several years ago. We particularly wish to express our thanks and appreciation to Kenji Adachi, former Commissioner of the Agency for Cultural Affairs, and to Hisashi Yasujima, the present Commissioner, for their generous support of the exhibition. We are also deeply grateful to those staff members of the Agency and of the Tokyo National Museum who cooperated wholeheartedly with the writer in the actual realization of the exhibition. We would like to offer special thanks to Takashi Hamada, Director of the Fine Arts Division of the Agency, Tomoya Suzuki, Curator of Applied Arts in the same division,

and Mrs. Aiko Noda, Secretary. At the Tokyo National Museum we are particularly grateful to Seizo Hayashiya, Curator of Applied Arts, and Gakuji Hasebe, Curator of Far Eastern Art, as well as Yoshiaki Yabe, Assistant Curator in charge of ceramics. Hiroko Nishida and Catherine A. Kaputa, the latter a former member of the Seattle Art Museum's Asian Department, devoted much time and knowledge to helping with the research for the entries and with the translation of Japanese texts. Francis B. Tenney, former Counselor for Public Affairs at the U.S. Embassy in Tokyo, and John F. McDonald, Cultural Exchanges Officer at the Embassy, also generously gave their advice regarding various administrative and technical aspects of the exhibition and acted as intermediaries in certain matters relating to the official role of the governments of Japan and of the United States. In this respect we are also grateful to Peter Solmssen, Advisor on the Arts, Office of International Arts Affairs, U.S. Department of State, who helped expedite certain procedural details between the two governments.

Among the many other individuals in Japan who have contributed so much to the realization of the exhibition, we would especially like to thank Bunsaku Kurata, an old friend and colleague, who held the important position of Counselor of the Agency for Cultural Affairs at the time of the exhibition's inception and is today the distinguished Director of the Nara National Museum.

An exhibition as complex as this one, involving so many museums and private lenders throughout Japan, inevitably requires large expenditures and the participating museums are grateful to the Government of Japan and to the Agency for Cultural Affairs for providing the funds for expenses incurred in Japan, including those for the assembling and packing of the loaned objects and their unpacking and dispersal upon their return, as well as costs for photographs and color transparencies for the catalogue. In the United States, the organizers of the exhibition would like to thank the National Endowment for the Arts in Washington, D.C., especially Nancy Hanks, Chairman, and John R. Spencer, Director of Museum Programs, for the generous grants awarded to the Seattle Art Museum and to Asia House Gallery in support of the exhibition and the catalogue. Our appreciation is also extended to the Asia Foundation, Tokyo and San Francisco, especially its Liaison Representative in Japan, James L. Stewart, for financial assistance in support of travel expenses for two accompanying Japanese curators. The JDR 3rd Fund showed an early interest in the exhibition and our thanks for their financial aid, including travel expenses for one of the Japanese curators, are extended to Richard S. Lanier, Director of the Asian Cultural Program, and to Porter A. McCray, his predecessor.

Special thanks and appreciation are owed to the many members of the Seattle Art Museum staff who assisted in the production of the catalogue and other important aspects of the exhibition, notably William J. Rathbun, Associate Curator of the Department of Asian Art, Yin-wah Ashton, Assistant Curator, and Noriko Fujita, Department Secretary. Elizabeth de Fato, Librarian, generously contributed her time to proofread the manuscript. The Registrar, Ellen Clattenburg, and William J. Lahr, Shipping Supervisor, devoted many hours of their time to working out technical details pertaining to shipping, packing, and security arrangements. Neil Meitzler, Museum Designer, can always be counted upon to do a splendid job in installing the exhibition at the Seattle Art Museum. Jo Nilsson, Photo-Slide Librarian, and Paul Macapia, Museum Photographer, and his staff assisted generously with photographic work required in connection with the catalogue production. The writer would also like to express his deep appreciation to Willis F. Woods, Director of the Museum, for his keen interest in the exhibition and his loyal support of the entire project.

The exhibition would not have been possible without the cosponsorship of Asia House Gallery, which assumed responsibility for the publication costs of the exhibition catalogue and provided generous financial assistance for other aspects of the exhibition, especially travel expenses associated with its organization. The writer would like to extend his warmest thanks to Allen Wardwell, Director of Asia House Gallery, and to Virginia Field, former Associate Director, for their unswerving support of the exhibition and their indispensible supervision of this publication. Virginia Field, in particular, gave much of her knowledge and expertise derived from her long association with the Asia House Gallery exhibition program to overseeing the initial stages of the catalogue production. Since her retirement in 1976, the catalogue has become the responsibility of Sarah Bradley and Susan Williams O'Sullivan; our sincere thanks are extended to them as well. Miyeko Murase, Professor of Art History at Columbia University, also provided invaluable assistance in securing photographs for the catalogue.

Finally, we would like to thank our professional colleagues in the other museums participating in this exhibition: Richard F. Brown, Director, and David Robb, Curator, of the Kimbell Art Museum; and René-Yvon Lefebvre d'Argencé, Director, and Yoshiko Kakudō, Curator of Japanese Art, at the Asian Art Museum of San Francisco, The Avery Brundage Collection. We are honored to be able to share this exhibition with these distinguished institutions and with Asia House Gallery and would like to thank everyone on their staffs involved in this project for their loyal assistance and cooperation.

Henry Trubner
Associate Director, Seattle Art Museum

Lenders to the Exhibition

Taki Hara

Kanichirō Ishibashi

Shūichi Kato

Yasuhiko Mayuyama

Shinako Mitsui

Yone Miyawaki

Yōichi Nakajima

Hachirō Ninomiya

Gorō Sakamoto

Yūji Sano

Shigeo Shimizu

Seiichi Sorimachi

Tsuneji Suzuki

Mitsumasa Takano

Tokiji Takano

Ryōji Tanimura

Shōnosuke Toda

Takashi Yanagi

Agency for Cultural Affairs

Daigo-ji

Egawa Museum of Art

Eisei Bunko Foundation

Fukuoka City Historical Material Museum

Gotō Art Museum

Hatakeyama Memorial Museum

Honnō-ji

Idemitsu Art Gallery

Itsukushima Shrine

Kanzeon-ji

Kyoto National Museum

Nara National Research Institute of Cultural Properties

Okinawa Prefectural Museum

Seikadō Bunko Foundation

Tokyo National Museum

Umezawa Memorial Museum

Chinese Ceramics in Japanese Collections

This exhibition of Chinese ceramics consists of *densei-hin*, pieces that have been handed down through many generations in Japan, and ceramics excavated from Japanese historical sites. All were carefully chosen in order to illustrate trends in collecting during the millennium from the eighth through the seventeenth centuries when Chinese ceramics were vigorously being imported to Japan, both commercially and as presents or souvenirs brought home by Japanese visitors to the continent. In addition to the *densei* and excavated pieces, several Chinese ceramics purchased early in this century were included in order to demonstrate contemporary Japanese tastes and give the exhibition an all-encompassing nature.

Many of the objects presented are unparalleled examples of their kind. Of particular importance are the two three-color glazed covered jars (Nos. 2, 3), the three-color glazed vase (No. 4), the blue and white jar with a dragon design (No. 40), and the underglaze red jar with a floral design (No. 43). Since ceramic fragments similar to No. 4 were excavated at eighth-century sites, we can assume that T'ang three-color glazed ware was being imported to Japan around this time. The two jars (Nos. 2, 3) and the vase (No. 4) are representative examples of this type of ware. Yüan blue and white ware has recently been excavated at various sites including Okinawa (No. 42abc) and Ichijōdani in Fukui Prefecture. However the excavations yielded only broken fragments; therefore the jar (No. 40) was selected as an example which has survived in perfect condition. Although no Yüan underglaze red porcelain has yet been excavated in Japan, the large jar (No. 43) is a world-famous masterpiece and was included at the request of the American committee members.

The primary purpose of this exhibition to be held in America is to illustrate the ways in which the Japanese have historically viewed Chinese ceramics, particularly the distinctive nature of the Japanese aesthetic evaluation of these wares. Moreover, the exhibition demonstrates that Chinese ceramics found in Japanese collections are quite different from Chinese wares exported to Korea, Southeast Asia, the Middle East, East Africa, and Europe. Thus, this exhibition also provides valuable evidence for studying the history of the exportation of Chinese ceramics to Japan.

HISTORICAL BACKGROUND

Since various objects made in China during the Han dynasty (221 B.C.–A.D. 220) have been found at Yayoi period (second century B.C.—third century A.D.) sites in Japan, the beginning of the transmission of Chinese culture to Japan can be traced at least this far back in history. However, no Han pottery has yet been excavated. By

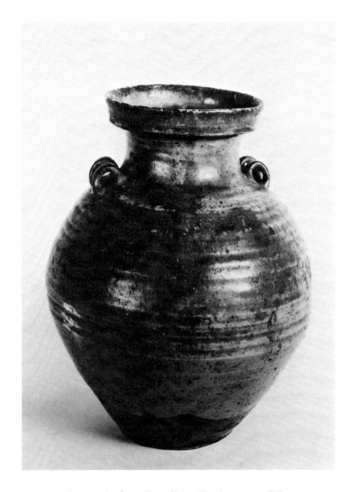

FIG. 1 Jar with four handles. Yüeh ware, 6th century. Tokyo National Museum.

the fourth and fifth centuries, there was a more or less steady flow of Chinese culture into the Japanese archipelago, but it was not until the Nara period (645–794) that Chinese ceramics were first mentioned in Japanese documents. Among the earliest examples of Chinese ceramics brought to Japan is the celadon jar with four handles preserved at the Horyū-ji in Nara (fig. 1). The jar must have reached Japan prior to 734 as it was listed in the temple inventory of that year. It is likely that the celadon jar in the shape of a bronze *fu* (No. 1) was also brought to Japan during the eighth century since many fragments of this type were excavated at the Heijō Palace site in Nara.

Three-color glazed pottery of the T'ang dynasty was also imported to Japan in the Nara period. In 1965, more than 120 shards of three-color ware were found at the Daian-ji site in Nara. Many pieces, though none in perfect condition, were also excavated on the island of Okinoshima near Fukuoka in 1969. Both sites, which are

dated to the eighth century, brought to light many important examples of T'ang three-color glazed ware rarely found outside China.

During the Heian period (794–1185) Chinese ceramics, particularly celadon and white porcelain bowls, ink slabs, and jars, were used as fashionable household utensils by those of high status, though the imported wares were still regarded as precious objects. It is generally believed that the transmission of Chinese culture to Japan declined after 894 with the cessation of official missions between the two countries. The ceramic trade persisted, however, and a number of Chinese ceramics were imported to Japan during the tenth and eleventh centuries, the Yüeh celadon ewer (No. 7) being a representative example.

A large number of tenth-century Yüeh celadons were excavated at the official reception hall (*koro-kan*) in Dazaifu on Kyushu. It is thought that the hall was used as a trading center after official diplomatic relations with China were terminated in 894. From Dazaifu, Chinese ceramics were distributed to various places in Japan, but it is rather difficult to ascertain the kind of wares imported in the late Heian period. The only examples definitely known to have reached Japan at this time were excavated from sutra mounds dating from the eleventh and twelfth centuries. The sutra container (No. 11) and several small boxes with covers (Nos. 12, 13abcd) were originally buried in sutra mounds together with Buddhist sutras in containers, images of the Buddha, religious utensils, mirrors, coins, and swords. The white porcelain ewer (No. 15), the jar (No. 14), and the two *mei p'ing* vases (Nos. 9, 10) were probably also imported during this period. Most of these pieces were produced in southern China,

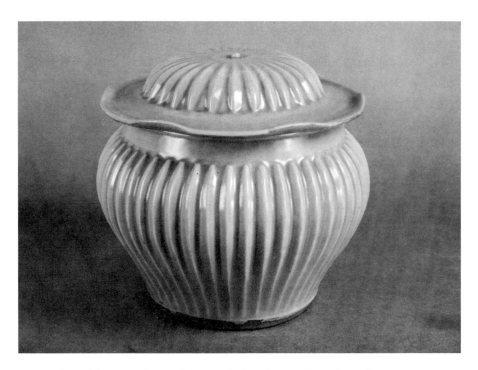

FIG. 2 Jar with cover. Lung-ch'üan celadon, late 13th-early 14th century. Excavated near Kamakura.

there being few pieces imported from northern China at this time. This may have been due to the fact that most trade routes to Japan originated from the coastal area of southern China, where many kilns produced celadon and white porcelain wares during the T'ang and Northern Sung dynasties.

Many fine Chinese ceramics were imported to Japan during the Kamakura period (1185–1333) as is clearly documented by excavated pieces as well as surviving *densei-hin*. More than ten thousand fragments were found on the beach near the city of Kamakura where the capital of the military government was located at that time. Several examples of celadon ware in perfect condition, such as the bowls, No. 30abc, and the covered jar, fig. 2, were also found at historical sites near Kamakura. In addition, a number of Sung and Yüan ceramics have been found in the cities of Hakata and Dazaifu in Fukuoka Prefecture (Nos. 15, 31a-j), the Kusado Sengen-chō site in Hiroshima Prefecture, and at Jūsan-minato in Aomori Prefecture.

Celadons formed the majority of Chinese ceramics exported to Japan during the Kamakura period. Many were beautiful examples of Sung dynasty Lung-ch'üan ware, but numerous pieces of coarse celadon from Chekiang and Fukien provinces have also been found. White porcelain and black glazed ware have been discovered as well. As in the Heian period, these were primarily products of southern China.

Besides these excavated pieces, quite a number of *densei* celadon pieces exist in Japan, and some of them undoubtedly were imported during the Kamakura period. Although most were produced at non-imperial kilns, there are several superb pieces which may well have been created at imperial kilns. Among the finest types of celadon found in Japan are light blue green *kinuta* celadon (Nos. 22, 25, 26, 30ab) and celadon with iron spots (No. 27).

It is thought that the production of *temmoku*, the Japanese name given to Chien ware, had already started by the first half of the twelfth century, but the peak period of its importation to Japan occurred during the thirteenth century when a great volume of *temmoku* tea bowls was produced at kilns in Fukien Province. The custom of drinking tea with *temmoku* bowls was introduced to Japan by Zen Buddhist monks and it gradually became popular among military men, the aristocracy, and other groups.

During the Muromachi period (1333–1568), a wide variety of Chinese ceramics were brought to Japan, a fact verified by contemporary literature as well as by excavated finds. By the fifteenth century, the interior decoration of tea rooms was far more sophisticated than it had been previously, stimulating a demand for new types of Chinese ceramics. The most renowned collection of Chinese art objects in this period was that formed by Ashikaga Yoshimasa (1435–1490), the eighth Ashikaga shogun. An inventory of Yoshimasa's collection is included in the *Kundaikan Sōchō-ki* written in 1476. In addition to cataloguing the shogun's collection, the book provides valuable information on the classification, connoisseurship, and use of Chinese ceramics at that time. The method of ranking and evaluating Chinese ceramics found in this book is considered superior even today. For example, the *yōhen* (iridescent) *temmoku* bowl called *Inaba Temmoku*, which was given the highest ranking, is still greatly admired by both Japanese and foreign connoisseurs.

Many exquisite pieces used in the Muromachi period were reverently passed down from generation to generation by feudal lords, rich merchants, and tea masters of the Momoyama and Edo periods and survive to this day. In addition, a large quantity of coarse Chinese ceramics, mainly blue and white, white porcelain, and celadon, was also imported to Japan from the fifteenth century onward.

By the late fifteenth century, the custom of drinking tea had become popular not only among the aristocracy and rich merchants, but also among common people. Bowls of tea were sold on street corners and tea houses were established even in small towns. This vogue for tea drinking, as well as the ideas developed by certain influential sixteenth-century tea masters, revolutionized the tea ceremony from an elaborate, ostentatious ritual into a simpler, seemingly humble affair.

Known as the *wabi* (quiet, unassuming) style, this new version of the ceremony was first introduced by Murata Jukō (1422–1502) and later practiced and refined by wealthy merchants in Sakai, Kyoto, and Nara. The final maturation of *wabi*-style tea occurred under Sen-no-Rikyū (1522–1591), who advanced the simple, but profound, creativity of the tea ceremony. As a result, a variety of coarse ceramic wares such as Korean tea bowls and native Japanese wares came into use. Rikyū, in particular, was fond of unusual *wabi*-style tea utensils. In the course of the development of *wabi* tea, the kinds of ceramics imported from China were also strongly influenced. For example, rather crudely made *temmoku* and Lung-ch'üan celadon pieces were highly praised, while fine quality celadon and *temmoku* tea bowls were given a lower ranking.

Blue and white porcelain was also imported in great quantity in the sixteenth century, but it was not usually used for *wabi* tea utensils. Only certain kinds of blue and white tea bowls such as those with a design of pavilions and clouds (see No. 45) were praised by tea masters and sometimes mentioned in tea ceremony memoranda. Although overglaze enameled ware was probably imported from around the mid-sixteenth century, it was not favored by *wabi* tea masters either.

In the first half of the seventeenth century, however, Chinese ceramics once again became exceedingly popular for use in the tea ceremony. The quantity of the coarse Chinese export ware called Swatow ware (*gosu aka-e* in Japanese) exported to Japan at this time must have been enormous, for it is known that during one year in the 1630's more than fifty thousand pieces were brought over by a single Sakai merchant. Of course, resplendent, high quality pieces, particularly *ko sometsuke* and *Shonzui* wares, were also created for the Japanese market. These two types were made to order in China at the request of Japanese tea masters. Many copy native Japanese wares such as Oribe ware (fig. 3) in shape and design and clearly embody Japanese aesthetic preferences (see Nos. 66, 67, 70).

THE DEVELOPMENT OF JAPANESE AESTHETIC APPRECIATION
OF CHINESE CERAMICS

The appreciation of Chinese ceramics was already firmly established in Japan by the tenth century. At this time, although Chinese vases, incense burners, ink stones, and the like were admired as beautiful, finely crafted, foreign made products, they were used functionally in the everyday life of the aristocracy. An example is the famous

NO. 24 Tea bowl, named *Bakō-han*. Lung-ch'üan celadon, 12th-13th century.
Diam. 6⅛ in. (15.4 cm.). Tokyo National Museum.

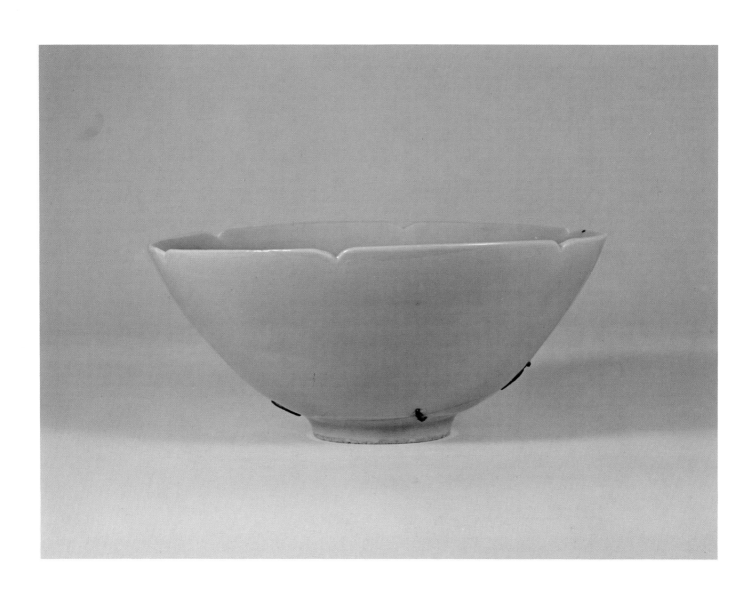

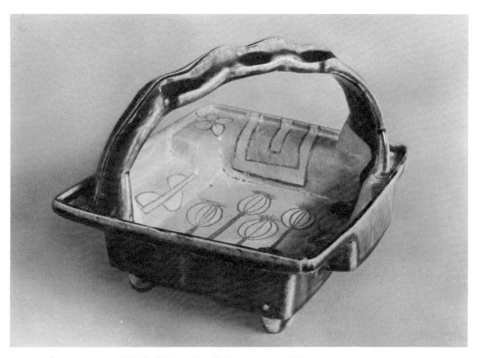

FIG. 3 Square tray with bail handle. Oribe ware, 16th century.

white porcelain ink stone, said to have been owned by the Heian courtier Sugawara Michizane (845–903), which is now a National Treasure preserved in the Tenmangu Shrine in Osaka. Records reveal that in the eleventh century Chinese ceramics such as white porcelain and Yüeh celadon were sought by Japanese Buddhist monks who visited China. Again, their efforts reflected the desire for finely crafted pieces not available on the native Japanese market.

An important piece revealing Japanese attitudes toward Chinese wares is the celadon bowl named *Bakō-han* (No. 24). According to tradition, this superb celadon bowl was given to the famous twelfth-century warrior Taira Shigemori by a Chinese priest. Three hundred years later the bowl entered the collection of the shogun Ashikaga Yoshimasa (1435–1490). The bowl broke and Yoshimasa had it sent to China so that an identical piece could be made. Since a comparable example could not be produced in China at that time, however, the bowl was repaired with the large metal clamps which have given rise to its nickname *Bakō-han* (Large Locust Clamp). The history of this piece underscores the esteem in which prized Chinese ceramics were held in Japan at this early period.

Further understanding of the Japanese aesthetic appreciation of Chinese ceramics can be gained from the *Kundaikan Sōchō-ki*, the catalogue of art objects collected by Yoshimasa. This list reveals the variety of *temmoku*

tea bowls imported to Japan before the fifteenth century, such as *yōhen* (iridescent glaze), *yuteki* (oil spot, No. 32), *kensan* (hare's fur, Nos. 33, 34), *usan* (black glaze), *taihi* (tortoise shell, Nos. 36, 37), and *haikatsugi* (ash-sprinkled glaze, No. 35). A number of jars for tea leaves (*chatsubo*) were mentioned in the list. These were probably imported from southern China and achieved great popularity with the Japanese. Tea caddies (*cha-ire*) were also imported between the thirteenth and fifteenth centuries, and an elaborate system of classification for them was evolved.

While the tradition embodied in the *Kundaikan Sōchō-ki* stressed the role of Chinese ceramics as art objects for appreciation, a new attitude, fostered by the evolving tea ceremony, emphasized the function of Chinese ceramics as tea utensils. At the same time, the connoisseurship of Chinese ceramics came to reflect the new aesthetics developed for the Japanese tea ceremony.

With the development of the *wabi*-style tea ceremony in the sixteenth century, attitudes toward Chinese ceramics changed radically. Tea masters of *wabi* tea did not favor refined, perfectly executed Chinese ceramics, such as Lung-ch'üan celadon (No. 24) and *temmoku* tea bowls (see Nos. 32–34, 36, 37). Pieces made of a coarse yellowish celadon called Jukō celadon and grayish brown *haikatsugi temmoku* tea bowls (No. 35) were more in keeping with their tastes. Because refined Chinese ceramics had no place in *wabi* tea, it is difficult to ascertain the precise nature of the Chinese wares imported to Japan at this time.

Another watershed in the history of Japanese appreciation of Chinese ceramics occurred in the first half of the seventeenth century when a quantity of Chinese porcelain, chiefly blue and white ware, was produced specifically for the Japanese market. The aesthetic preferences of Japanese tea masters were reflected in types such as *ko sometsuke* (Nos. 61–68) and *Shonzui* wares (Nos. 71–75). It seems likely that some enameled ware produced at kilns in Fukien and other southern provinces was also either made for the Japanese market in general or made to order for Japanese tea masters, although this has not yet been substantiated. The custom of requesting Chinese porcelain made to certain specifications was a development of the early seventeenth century and reflects direct Japanese influence over the types of wares imported from the continent. However, the practice of ordering Chinese ceramics to Japanese specifications was more or less abandoned after the end of the seventeenth century when fine blue and white and enameled wares were produced in Japan.

A type of Chinese porcelain highly acclaimed in Japan during the first half of the seventeenth century was *kinran-de* ware produced during the Chia-ching period (Nos. 51–55). Collections in Japan have the largest number of high quality *kinran-de* pieces in the world, and except for examples in the Topkapi Sarai Museum in Istanbul, few exist outside of Japan. *Kinran-de* ware was avidly collected in Japan and native copies were produced at various Japanese kilns.

It is important to note that many pieces in this exhibition bear individual names, such as the celadon vase called "Mount Yoshino" (No. 44). In the context of the tea ceremony as it evolved in Japan, a piece transcended its role as a mere object and was appreciated almost as a fellow human being with its own physical character, personality, and genealogy. To capture the individuality of a piece, a tea master or connoisseur sometimes gave it a name suggested by qualities of glaze, shape, or design, or the mood it evoked. The naming of these objects symbolizes the unique, highly personal reaction of the Japanese towards ceramics.

Although it is not known for what purpose they were originally made in China, many of the *densei* pieces were adapted for use in the tea ceremony as tea caddies, water jars, flower vases, and incense boxes. These have

been carefully preserved and are generally of a quality and beauty not seen in the excavated pieces. The *densei-hin* assembled here provide a rare opportunity for studying the history of Japanese aesthetic taste.

Seizo Hayashiya

The History of Chinese Ceramics in Japan

Ceramics from China have been treasured and collected by the Japanese for more than 1200 years. Many noted and characteristic examples of these ceramic wares have been assembled here from public and private collections in Japan to show the close cultural and artistic relationship which has long linked the two countries. Although a few pieces have been chosen to illustrate the types of wares that found favor among Japanese collectors in the twentieth century, the emphasis of the exhibition is on ceramics imported to Japan between the eighth and early seventeenth centuries and the role these pieces played in Japan's cultural history.

The exhibition may be divided into two principal groups: *hakkutsu-hin*, or "excavated pieces," and *densei-hin*, or "handed down pieces." The *densei-hin* are celebrated pieces which were brought to Japan in an early period, often became the property of an important temple, famous tea master, or noted collector, and were "handed down" from generation to generation.

The Chinese wares excavated in Japan are important links in the study of Japanese ceramics and contribute a great deal to our knowledge of their historical development. Unfortunately, it was not until the Taishō era (1912–1926) that the serious study of excavated Chinese ceramics was started with the aid of numerous scholars and scientists throughout Japan. Up to that time, excavated pieces were regarded as little more than curios and were often reburied without a proper record of the piece, or even of the excavation site itself having been made. After the Second World War fresh impetus was given to scientific excavation and the revival of interest in Japanese archaeology and history continues unabated to this day.

The course of history in Japan has been distinguished by successive waves of influence from the Asian mainland, both directly from China and through Korea, which have resulted in strong cultural, artistic, and religious ties between China and its neighbors to the east. The stylistic and artistic trends from the mainland were, however, invariably absorbed into the mainstream of Japanese culture and in the end Japanese concepts and aesthetics always prevailed. Japanese art has maintained a flavor and character distinctly its own.

The first significant influx of cultural and artistic influences from mainland China and Korea came in the sixth century in the wake of the introduction of Buddhism. Diplomatic relations were established with the Three Kingdoms of Korea and craftsmen emigrated to Japan to provide the objects of worship which Buddhism required for its use. Buddhist sculpture of the Asuka period (552–645) represents an early example of how Japanese art forms absorbed Chinese and Korean influences and, at the same time, asserted distinctively Japanese characteristics.

During the Nara period (645–794), which paralleled the early T'ang dynasty (618–906), China exerted an even stronger cultural and religious impact upon all her neighbors but particularly on Japan. Not only were

Buddhist architecture, sculpture, painting, and the decorative arts in Japan heavily influenced; government organization, the layout of cities, daily dress, food, music, and dance also reflected close contacts and multiple borrowings from T'ang China. Even Nara, which became the new Japanese capital in 710, was modeled closely upon the grid plan of Ch'ang-an, the T'ang capital.

Japanese ideals and concepts quickly began to reassert themselves, however, as the power of the T'ang empire declined, following the abdication of the Emperor Hsüan-tsung (Ming Huang) in 755 and the unsuccessful revolt of the Tartar general An Lu-shan. This brought to an abrupt end the Golden Age of T'ang China, for although the rebellion was crushed and the empire re-established, it never again attained its former greatness and its powerful position of influence.

Chinese ceramics in Japanese collections tell us a great deal about the cultural and artistic relationship between China and Japan and have often been good indicators of the direction in which Japanese ceramics would develop. As might be expected, Japanese ceramics reflect the influence of China, as well as that of Korea, most clearly during those periods when the influx of artistic, cultural, and religious concepts from the Asian mainland flowed most freely towards Japan. Such a relationship is clearly evident, for example, when one compares typical three-color (san-ts'ai) wares of the T'ang dynasty, a number of examples and excavated fragments of which are included in this exhibition (Nos. 2–5), with so-called Nara sansai of the eighth century.[1] The influence of T'ang ceramics is undeniable, but differences in the shape, body, and combination of colored glazes leave little doubt as to the Japanese manufacture of Nara sansai.

The T'ang three-color wares are the earliest Chinese ceramics excavated in Japan. This pottery, decorated with polychrome lead silicate glazes fired at low temperature, was made near Ch'ang-an, the T'ang capital, and in the vicinity of Lo-yang, an important cultural center and a former capital in Honan. T'ang three-color fragments have been excavated in Korea; on the island of Okinoshima off the northern coast of Kyushu, near Fukuoka; at Daian-ji in Nara (No. 5); and also reportedly in Indonesia and at Fostat (Old Cairo) in Egypt. This ware was made especially as burial articles for noble families and enjoyed its greatest popularity in China when the T'ang court was most powerful, early in the eighth century. Pieces imported to Japan were probably brought back by envoys sent to China at that time. The presence of excavated T'ang three-color fragments in Japan suggests that a close cultural relationship was maintained between the ruling aristocracy of Tempyō Japan and T'ang China.[2]

Three-color ware comprises the largest and most popular group of T'ang ceramics exported to Japan, followed by high-fired Yüeh ware from Chekiang. The exhibition includes an early Yüeh jar (No. 1) and three vessels decorated with three-color glazes (Nos. 2, 3, 4), as well as a group of three-color and marbled ware fragments excavated at the site of the main hall (kondō) of the Daian-ji near Nara (No. 5), and another group of shards excavated at the site of the old Heijō Palace of the Nara court (No. 6). The latter group includes several fragments of early white ware which show a close relationship to northern type Ting ware. The excavation of the ancient site of the Daian-ji carried out about twenty years ago also yielded thirty ceramic headrests of T'ang polychrome ware, proving that T'ang polychromes were known and in use at the ancient capital of Nara.[3]

These finds from the Nara area and from the excavations carried out at Dazaifu, Fukuoka Prefecture, are undisputed evidence of the early presence and knowledge in Japan of T'ang three-color ceramics, Yüeh and other green ware, as well as T'ang white ware. There is no longer any doubt that Japanese craftsmen of the Nara and

24

early Heian periods were able to study first-hand the ceramic products of China from the T'ang and Five Dynasties periods.

The Heijō Palace site has also yielded numerous examples of Japanese Nara *sansai* and green-glazed wares derived from Chinese prototypes but produced in Japan. Most of these seem to have been intended for practical use. Among the finds are polychrome tureens and rice pots whose exteriors are scorched black, suggesting that they were actually used for cooking. This is one important respect in which Japanese three-color and green ware differ from their Chinese counterparts, which served a strictly ornamental purpose.[4]

The official position of Nara as the capital of Japan came to an end in 794 with the move of the court to Heian-kyō, the City of Tranquil Peace in what is present-day Kyoto, which marked the beginning of the Heian period. T'ang influence persisted for a while and the new capital, like Nara, was laid out along Chinese lines. When the power of T'ang China began to disintegrate in the ninth century, however, there was a sharp decline in the influence which Chinese ceramics exerted on the growing ceramic production of Japan. Official relations with China were severed at the end of the ninth century when Japan stopped sending official missions to the Chinese mainland.[5]

The trade in ceramics continued, however, and among the Chinese wares brought to Japan in the Heian period (794–1185) is an important Yüeh ware ewer (No. 7), which may once have been in the possession of the powerful Fujiwara family. The ewer, which dates to the tenth or eleventh century, was discovered in 1937 at the site of the Jōmyō-ji, a temple on the outskirts of Kyoto that was closely linked to the Fujiwaras. It is even possible that the ewer may have been donated to the temple by the Fujiwaras, who were the owners of many fine examples of Chinese ceramics.

Among the major sites presently under investigation are the ruins of Kusado Sengen-chō, on the outskirts of Fukuyama city, Hiroshima Prefecture, visited by the writer in November 1976.[6] The site has already yielded important finds, including examples of early Japanese wares as well as shards of Chinese Lung-ch'üan and Northern Celadon ware, so-called Honan *temmoku*, and Korean inlaid celadon of the Koryō period (918–1392). All the wares, Chinese, Japanese, and Korean, were actually used at this site, which in medieval times was a flourishing trading center whose main street connected directly with the Myō-ō-in, an important temple located in the mountains nearby. Once again the finds attest to the close commercial and cultural interrelationship between Japan, China, and Korea, with Japan being the recipient and benefactor of the foreign trade.

Another major excavation project is under way at Asakura Castle, Fukui city, on the Japan Sea coast. Destroyed by Oda Nobunaga (1534–1592) in 1573, the castle had been an active center for about 300 years and the excavations have yielded many fragments of Yüan blue and white porcelain and Lung-ch'üan celadon, as well as native Japanese, Seto, Tokoname, Bizen, and Karatsu ware. Future excavations are also planned for the site of Nagoya Castle (not to be confused with the castle by the same name in Nagoya city), at the northwestern tip of Kyushu, not far from the busy port city of Karatsu. This was the fortress where Toyotomi Hideyoshi (1536–1598) was encamped while his armadas set sail for Korea on their two ambitious expeditions in 1592 and 1597. Later dubbed the "Pottery Wars," these expeditions were unsuccessful militarily. They were, however, to become a significant part of the history of Japanese ceramics, for the Korean potters brought back to Japan after the wars made Karatsu the center of production of Korean-type Karatsu stonewares. Near the Nagoya Castle

site is the small fishing village of Yobuko, which was a bustling commercial center in Hideyoshi's time when travelers en route to Kyoto from Hirado, an island off the northwestern tip of Kyushu, stopped there for rest and supplies. The scheduled excavations of Nagoya Castle and its surroundings are therefore almost certain to yield additional important ceramic finds.

Most of the Chinese ceramics excavated in Japan have come from sutra mounds (*kyōzuka*), where copies of Buddhist sutras and other articles were buried to protect them during the *Mappō* (End of the Law). According to ideas current in the late Heian and early Kamakura periods, mankind was entering a final stage in the decline of the Buddhist Law and the faith would not revive until Maitreya, the Buddha of the Future, arrived to initiate a new cycle of the Law. There are more than three hundred recorded sutra mounds in Japan, ranging in date from the late Heian to the early Kamakura period, where Chinese ceramics have been found. These ceramics form a distinctive and important group of wares which include sutra containers (*kyōzutsu*) with lids (No. 11), small covered boxes (*gosu*) of the molded type with *ch'ing-pai* glaze (Nos. 12, 13), and a variety of vases (Nos. 14, 15) and dishes, some with a yellowish brown celadon type glaze over a design painted in iron brown pigment on white slip (No. 16). The majority of *ch'ing-pai* glazed porcelains excavated from sutra mounds dates from the second half of the twelfth century, which suggests that this was the period when the largest number of Sung dynasty wares with bluish white glaze of the *ch'ing-pai* type were imported to Japan.

Chinese ceramics imported to Japan during the Heian and the Kamakura periods (794–1333) include many different types, but most fragments discovered at excavated sites are those of celadon glazed wares (Nos. 29–31, 42), white porcelain (No. 31), *san-ts'ai* and related green glazed wares (see No. 17),[7] black and brown glazed wares, and wares with yellow glaze over iron brown designs (No. 16).

It should be noted that formal commercial relations between Japan, Sung China, and Korea were re-established about 1200, bringing about the renewed importation of Sung ceramics to Japan. White porcelain, celadons, and *ch'ing-pai* type wares were eagerly sought both by members of the ruling classes and by the Buddhist clergy, resulting in the import of large quantities of these wares. There is no doubt that the Seto potters, in particular, were strongly influenced by Chinese ceramics of the Sung dynasty, the knowledge of which enabled them to introduce new shapes and glazing techniques. Ko Seto (Old Seto) ware, with its high-fired stoneware bodies and intentionally applied glazes, represented something quite revolutionary in Japanese ceramic art.

Although the number of excavated pieces imported to Japan during the Heian and Kamakura periods shows a sharp increase over earlier imports from China, the pieces are often of inferior quality. The principal areas which have yielded finds from this later period are the area of Fukuoka in northern Kyushu, since ancient times the center of trade between China and Japan; the various ports along the Inland Sea; the Kinai district around Kyoto; and the area centering around the port city of Kamakura.[8] In the eighth century, the Japanese admiration for T'ang three-color ware had precipitated emulation which resulted in the development of new techniques in Japanese ceramics. Similarly the great appreciation for celadon and *ch'ing-pai* glazed wares imported to Japan prompted potteries in Japan to recreate the shapes and glaze colors of these imported wares. Examples clearly modeled on Yüeh and celadon shapes were developed in Heian period green-glazed ware. Somewhat later, at the Seto kilns, shapes common to *ch'ing-pai* and celadon were created in yellow and brownish black glazed wares in an apparent attempt to duplicate not only the color, but the glazing technique as well (see Nos. 7, 9,

10, 14, 15). Although Japanese potters seldom achieved the same glaze effects as the Chinese, especially in terms of color, their attempts led to a considerable technical advancement in the potting, glazing, and firing of medieval Japanese ceramics.⁹

The earliest *densei-hin* in Japan date from the Heian period and were highly esteemed by the Heian aristocracy. The exhibition includes what may well be the oldest *densei* piece in Japan, namely the famous tea bowl known as *Bakō-han* (No. 24), discussed by Seizo Hayashiya in his essay. Aside from its intrinsic historical importance, the bowl is a noted example of Lung-ch'üan celadon of the Sung dynasty.

The majority of Sung and Yüan dynasty *densei* pieces in the exhibition are examples of either celadon or black and brown glazed *temmoku* in its many variations. The celadons include the popular Lung-ch'üan ware from kilns in Chekiang Province (Nos. 21–23, 24–27), the rare and highly esteemed Kuan type celadon (Nos. 18, 19, 20), and several sub-types, such as *tobi seiji* or spotted celadon (Nos. 27, 28), *kinuta* (lit. mallet shape) celadon with its distinctive blue green glaze (Nos. 22, 26, 30ab), and *Tenryū-ji* type celadon (Nos. 30c, 44). Similarly, the *temmoku* examples range from the magnificent Chien ware bowl with oil spot glaze (No. 32), to examples with hare's fur glaze (Nos. 33, 34), Kian *temmoku* from Chi-chou, Kiangsi Province (Nos. 36, 37), and tea caddies (Nos. 38, 39) with *temmoku* type glazes.

Chinese *temmoku* wares had an important impact upon Japanese ceramics of the Muromachi period. From the late fourteenth century on, the Seto potters began to produce black and amber glazed wares of *temmoku* type, strongly influenced by imported Chinese wares, which enjoyed great popularity among the upper classes and the powerful Zen priesthood in Japan.

In the years from the late Muromachi through the early Edo period great advances in the technical quality and production of Japanese ceramics were made. This burst of ceramic activity was largely due to the demands of the tea ceremony (*cha-no-yu*), which had come to play a role of increasing importance in the life of the Japanese people. In China the drinking of tea had never been developed into an official ceremony or pastime, as it was in Japan by famous tea masters and arbiters of taste in the Muromachi period.

The fashion of drinking tea was first introduced from China in 1191 by Eisai, a Japanese Zen priest. Tea devotees especially favored the heavy, opaque green tea (*matcha*) made from powdered leaves. Murata Jukō (1423–1502), who was tea master to the Shogun Ashikaga Yoshimasa, was the person responsible for the establishment of tea drinking as a formal ritual during the latter part of the Muromachi period. He codified the rules of the tea ceremony and established the concept of *wabi-cha* (*wabi*, meaning quiet, solitary, and unassuming, was a term commonly applied to tea ceremony ceramics as well).

In the late Muromachi period, under the guidance of Takeno Jōō (1502–1555), the tea ceremony was further popularized and found support among the rising class of city merchants. At the same time, daimyo who had derived great power and wealth from the civil wars of the fifteenth and sixteenth centuries, and wealthy commoners who had also risen to prominence during those years, gradually replaced the aristocracy and clergy as patrons of the arts.

In the Momoyama period (1568–1615) with the support of the military rulers Oda Nobunaga, Toyotomi Hideyoshi, and Tokugawa Ieyasu and under the guidance of such tea masters as Sen-no-Rikyū (1522–1591) and his pupil Furuta Oribe (1544–1615), the tea ceremony rapidly grew into an aesthetic ritual of major importance,

which in turn greatly influenced the ideals and aspirations of Japanese art and culture. Toyotomi Hideyoshi (1536–1598), the great warrior and statesman, is particularly noted for the time and energy he devoted to the tea ceremony, which held an important place in the official affairs of state. In 1587 he called together all the tea masters, or *chajin*, and notables throughout the country and presided over a celebrated tea gathering that is said to have lasted ten days. The Sambō-in, a favorite retreat of Hideyoshi, and its famous landscape garden, both part of the Daigo-ji outside Kyoto, bear witness to the aesthetic taste and purity of spirit favored by Hideyoshi and his court. The small tea house at Sambō-in, with its rustic interior where Hideyoshi often secluded himself to perform the tea ceremony, expresses the simplicity and detached mood engendered by the tea ceremony and the corresponding belief in the solitary, abstract nature of Zen.

The essentials of tea taste in this period are contained in such frequently quoted, yet difficult to define terms as *wabi* (solitary, remote), *sabi* (antique or mellow from use), and *shibui* (astringent, quiet, reticent). The tea masters required simple wares for the performance of the tea ceremony and quiet ink paintings for the decoration of the *tokonoma* (alcove) in order to promote the ideals of *cha-no-yu*.

As a result they eagerly collected the simple *temmoku* wares and celadons of the Sung and Yüan dynasties, or their Japanese counterparts produced at the Seto and Mino kilns. Although Japanese kilns in the Muromachi and Momoyama periods developed many special wares produced exclusively to satisfy the growing demands of the tea ceremony, Japanese tea masters and their patrons continued to consider Chinese ceramics expressive of tea taste as their most prized and honored possessions. Later, in the seventeenth century, certain types of Chinese porcelain, notably the blue and white porcelain with *Shonzui* style decoration (Nos. 71–75), also found great favor among the tea masters.

Many of the Sung to early Ming *densei* pieces which were used in the tea ceremony have long, often famous histories of ownership attached to them, as for example the tea bowl named *Bakō-han* (No. 24) mentioned earlier. The *yuteki temmoku* bowl (No. 32) was once in the collection of the Momoyama tea master Furuta Oribe, who served the military rulers Oda Nobunaga, Toyotomi Hideyoshi, and Tokugawa Ieyasu. A brother of Nobunaga owned the tea caddy (*cha-ire*) named *Sōgo-nasu* after a famed merchant and tea master of the Muromachi period (No. 38), while Sen-no-Rikyū was given another tea caddy, known as "Rikyū Enza," by Hideyoshi (No. 39).

It is also a significant indication of Japanese aesthetic taste that the two ceramics in the exhibition designated as National Treasures, the celadon vase of Kuan type (No. 18) and the Chi-chou ware tea bowl with mottled black and brown glazes (No. 36), are both objects highly coveted for the tea ceremony. Several of the other celadons and *temmoku* examples, including the celadon vase with iron brown spots (No. 27) and the Lung-ch'üan celadon and *yuteki temmoku* tea bowls (Nos. 24, 32), have each been classified as an Important Cultural Property by the Government of Japan, in recognition of their intrinsic importance and rarity.

The Yüan and early Ming wares in the exhibition may be divided into two principal groups: the Lung-ch'üan celadons, illustrated by the splendid flower vase in the shape of an archaic Chinese bronze *ku* (No. 44), and the porcelains decorated in underglaze cobalt blue (No. 40) and underglaze copper red (No. 43). The shape and simple design of the celadon flower vase, which is of the *Tenryū-ji* type, made it ideally suited for the tea ceremony. It was once owned by Kobori Enshū (1570–1647), the famous Edo period tea master and arbiter of taste, who gave the piece the fanciful name of *Yoshino-yama* (Mt. Yoshino). The vase was also in the collection of Matsu-

daira Fumai (1751–1818), daimyo of Izumo and noted collector of tea ceremony utensils. A number of examples once in his collection are included in the exhibition (see also Nos. 32, 36).

The splendid blue and white jar decorated with dragons amid clouds from the Tokyo National Museum collection (No. 40), and the fine jar from the Umezawa Collection with an underglaze red decoration of floral designs (No. 43) are major examples of their respective types. Neither one is a true *densei* piece. It is generally believed that the blue and white jar was exported to Southeast Asia in the Yüan period, whereas the underglaze red jar came to Japan from China only a few years before the Second World War. Both pieces are, however, famous in Japan and reflect the discriminating taste of Japanese collectors in more recent times.

In the fifteenth through seventeenth centuries, porcelains of the highest caliber were produced in the imperial kilns at Ching-tê-chên and at several other ceramic centers, notably those in Fukien. A review of the Ming dynasty ceramics in the exhibition, however, reveals that the imperial Chinese wares from this period, especially those bearing the reign marks of Hsüan-tê (1426–1435), Ch'êng-hua (1465–1487), Chêng-tê (1506–1521), Chia-ching (1522–1566), or Wan-li (1573–1619) are virtually absent. Eagerly collected in the West, first in England and later in the United States, these imperial wares rarely found their way to Japan until the twentieth century. Rather, it was the non-imperial wares and particularly porcelains associated with the tea ceremony or adapted to it which became famous as *densei* treasured objects in Japan. The exhibition thus illustrates types of Ming porcelains seldom seen in the West.

Among the Ming porcelains which have enjoyed particular favor in Japan over the centuries are non-imperial blue and whites (Nos. 45, 46, 60–68); porcelains decorated in three-color enamels on the biscuit (*fa-hua*, Nos. 48, 49); wares with polychrome enamel decoration (*wu-ts'ai*), referred to as *aka-e* (red decorated) or *nishiki-de* (brocade style) in Japan; and the colorful Wan-li porcelains, boldly decorated in underglaze blue, often with the addition of overglaze polychrome enamels (Nos. 56–59). The *ko aka-e* porcelains with designs in overglaze red and green enamels (No. 47) and the wares decorated in the *kinran-de* style (Nos. 51–55) are other types which have been highly valued by Japanese collectors. Also consistently popular have been certain types of late Ming enamel and underglaze blue decorated porcelains represented by the *Tenkei aka-e* wares (Nos. 69, 70), Nanking *aka-e* (No. 76), porcelains decorated in *Shonzui* style (Nos. 71–75), and the important group of Swatow wares. Among the latter are enameled pieces (Nos. 77–79) and the infinitely rarer type with designs painted in slip, underglaze blue, and iron brown under a blue glaze. This type is represented here by the superb large dish with white slip decoration in *mochibana-de* (*mochi* flower style) from the Hatakeyama Collection (No. 80).

Ewers decorated with enamels and gold in the *kinran-de* style (see No. 53) are rarely seen in the West. Noted exceptions are the several magnificent *kinran-de* type ewers in the Baur Collection in Geneva, Switzerland.[10] Because the late Mr. Baur acquired the major part of his famous collection in Japan, including the splendid group of Ming porcelains, the Baur Collection is very much in the Japanese taste. Other wares illustrated here, notably the *Shonzui* and *Tenkei aka-e* types, are also represented in that unusual collection.[11]

As pointed out earlier, Chinese ceramics at various times guided the development of ceramic art in Japan. This influence, evident in the relationship of Lung-ch'üan celadon, Yüeh ware, *ch'ing-pai*, and *temmoku* with Ko Seto ware of the Kamakura period and Mino ware of the sixteenth century, becomes even more apparent when we examine the introduction and subsequent development of Japanese porcelain in the seventeenth and early

eighteenth centuries. In 1616, Ri Sampei, an immigrant Korean potter, discovered porcelain clay at Izumiyama, near Arita. This discovery, together with the advanced firing techniques that could be achieved with the use of the "climbing kiln" (*nobori-gama*) introduced from Korea, made possible the production of highly fired blue and white porcelain. Although Korean porcelains played an important role in the early phase of production of Japanese blue and white in the first half of the seventeenth century, the influence of Chinese Ching-tê-chên porcelain was soon evident. Similarly, once the Arita potter Sakaida Kakiemon had succeeded in producing the first Japanese porcelain with overglaze enamel decoration in about 1643, the development of Ko Imari and early Kakiemon porcelain was very much influenced by techniques, decorative designs, and ceramic shapes developed in China during the late Ming and early Ch'ing periods. Early Hizen blue and white ware from the Arita region of Kyushu owes much to Chinese *ko sometsuke* ware (Nos. 61–68). T'ien-ch'i (1621–1627) and Ch'ung-chêng (1628–1644) designs played a particularly vital role in the development of early Japanese blue and white and enamel decoration,[12] while the designs on Nos. 69 and 70 suggest Japanese Nabeshima porcelain of the first half of the eighteenth century.

Because Japanese admirers of the tea ceremony greatly favored *Shonzui, Tenkei aka-e,* Nanking *aka-e,* as well as the later Ming underglaze blue and enamel wares of Fukien and Kwangtung, represented here by the Swatow porcelains, there is also a clear connection between these and native Japanese ceramics. The unusual *ko sometsuke* rectangular dish with a hoop handle (No. 66) brings to mind Japanese tea ceremony wares such as Oribe and Taketori,[13] as well as later ceramics of the so-called Kyo-*yaki* type produced by Ogata Kenzan (1663–1743) and his followers in Kyoto. Other potters working in the Kyo-*yaki* tradition, such as Okuda Eisen (1753–1811), Eiraku Hozen (1795–1854), and Aoki Mokubei (1767–1833), also derived much of their inspiration from the underglaze blue and enamel decorated wares of the late Ming period.[14]

By presenting examples of the types of ceramics excavated and collected in Japan, this exhibition, the first of its kind in the West, directly reflects the Japanese taste and preference for special wares. This taste developed not only as a result of the nature of Chinese exports to Japan and the vicissitudes of history and geography, but also to a very large extent because of the particular nature and importance of the tea ceremony which vitally affected Japanese life and society. In the final analysis, the exhibition reflects very clearly the commercial, cultural, and artistic ties between China, Korea, and Japan, as well as the considerable influence these relationships exerted upon the course and development of Japanese art and civilization. It was in order to demonstrate the very special role that Chinese ceramics played in the cultural development of Japan to scholars, collectors, students, and the American people at large that this exhibition was organized as part of an official and ongoing program of cultural exchange between Japan and the United States.

Henry Trubner

Notes

1. *Ceramic Art of Japan: One Hundred Masterpieces from Japanese Collections* (Seattle: Seattle Art Museum, 1972), no. 12.

2. Gakuji Hasebe, *Chinese Ceramics Excavated in Japan* (Tokyo: Tokyo National Museum, 1975) pp. 60–61. This was the first exhibition of its kind held in Japan and an important source and inspiration for the present exhibition.

3. Tsugio Mikami, *The Art of Japanese Ceramics* (New York and Tokyo: Weatherhill/Heibonsha, 1972), p. 110.

4. Ibid.

5. Fujio Koyama, ed., *Japanese Ceramics from Ancient to Modern Times* (Oakland, California: Oakland Art Museum, 1961), p. 20, fn. 2.

6. The site was flooded twice by the changing course of the Ashida River, first in the Kamakura period and later in the thirteenth year of the Kambun era (A.D. 1673). The excavation work, which has been carried on for a number of years already, is scheduled to continue as part of a fifteen-year program, supported by the Hiroshima Prefectural Government. (See archaeological reports published by *Kusado Sengen-chō Iseki Chōsa Kenkyūsho* [Prefectural Research Institute of the Site of Kusado Sengen-chō], 1975–76.)

7. The dish lent by the Daigo-ji is a *densei-hin* rather than *hakkutsu-hin*, but nevertheless an important example of twelfth-thirteenth century southern Chinese three-color ware of Sung date.

8. Hasebe, *Chinese Ceramics*, pp. 61–62.

9. Gakuji Hasebe, "Connections Between the Ceramics of China and the Ancient and Medieval Ceramics of Japan," *International Symposium on Japanese Ceramics* (Seattle: Seattle Art Museum, 1973), pp. 55–59.

10. John Ayers, *The Baur Collection, Geneva: Chinese Ceramics*, vol. 2, (Geneva: Collections Baur, 1969), nos. A 177–A 180.

11. Ibid., nos. A 228–A 229.

12. *Ceramic Art of Japan*, no. 57; and Henry Trubner, et. al., *Asiatic Art in the Seattle Art Museum*. (Seattle: Seattle Art Museum, 1973), p. 263, no. 243.

13. *Ceramic Art of Japan*, nos. 45, 53.

14. Ibid., nos. 94, 98–99.

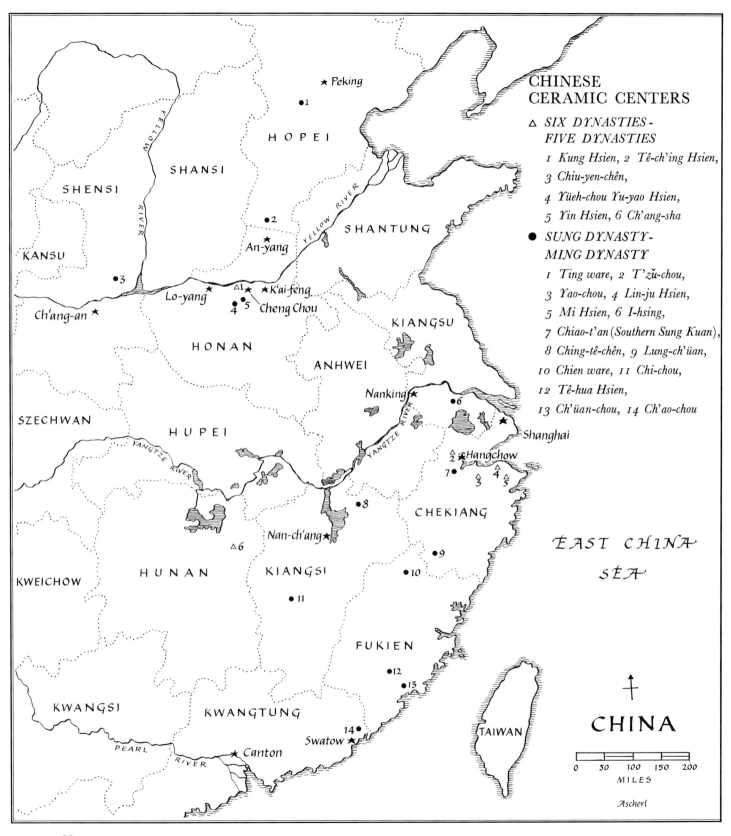

CHINESE
CERAMIC CENTERS

△ *SIX DYNASTIES -*
FIVE DYNASTIES

1 Kung Hsien, 2 Tê-ch'ing Hsien,

3 Chiu-yen-chên,

4 Yüeh-chou Yu-yao Hsien,

5 Yin Hsien, 6 Ch'ang-sha

● *SUNG DYNASTY-*
MING DYNASTY

1 Ting ware, 2 T'zǔ-chou,

3 Yao-chou, 4 Lin-ju Hsien,

5 Mi Hsien, 6 I-hsing,

7 Chiao-t'an (Southern Sung Kuan),

8 Ching-tê-chên, 9 Lung-ch'üan,

10 Chien ware, 11 Chi-chou,

12 Tê-hua Hsien,

13 Ch'üan-chou, 14 Ch'ao-chou

YELLOW RIVER

★ Peking

● 1

HOPEI

SHANSI

SHENSI

KANSU

● 2

An-yang ★

SHANTUNG

● 3

△1 ★
Lo-yang ★ ● ★ K'ai-feng
● ●
4 5 Cheng Chou

Ch'ang-an ★

HONAN

KIANGSU

ANHWEI

Nanking ★
● 6

★ Shanghai

SZECHWAN

HUPEI

YANGTZE RIVER

YANGTZE RIVER

△
2 ★Hangchow
7 ●
△
3 △ △
4 5

● 8

CHEKIANG

EAST CHINA

SEA

KWEICHOW

HUNAN

Nan-ch'ang ★

△ 6

KIANGSI

● 9

● 10

● 11

FUKIEN

● 12

● 13

TAIWAN

↑

CHINA

KWANGSI

KWANGTUNG

PEARL

RIVER

14 ●
Swatow ★

★ Canton

0 50 100 150 200
MILES

Ascherl

32

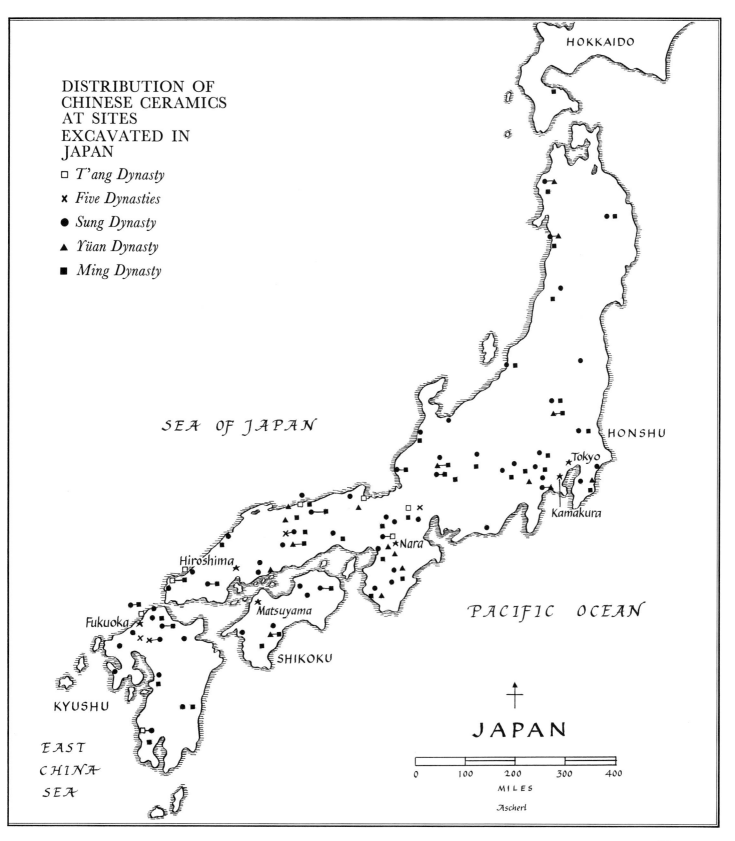

DISTRIBUTION OF
CHINESE CERAMICS
AT SITES
EXCAVATED IN
JAPAN

□ *T'ang Dynasty*

✕ *Five Dynasties*

● *Sung Dynasty*

▲ *Yüan Dynasty*

■ *Ming Dynasty*

HOKKAIDO

SEA OF JAPAN

HONSHU

Tokyo

Kamakura

Hiroshima

Nara

PACIFIC OCEAN

Matsuyama

Fukuoka

SHIKOKU

KYUSHU

EAST
CHINA
SEA

JAPAN

0 100 200 300 400
MILES

Ascherl

33

Chronology

CHINA		JAPAN	
Six Dynasties	220– 581	Nara period	645– 794
Sui dynasty	581– 618	Early Nara (Hakuhō)	645– 710
T'ang dynasty	618– 906	Late Nara (Tempyō)	710– 794
Hsüan-tsung (Ming Huang)	713– 755	Heian period	794–1185
Five Dynasties	907– 960	Early Heian (Jōgan)	794– 897
Liao Kingdom	916–1124	Late Heian (Fujiwara)	897–1185
Sung dynasty	960–1279	Kamakura period	1185–1333
Northern Sung dynasty	960–1127	Muromachi (Ashikaga) period	1333–1568
Southern Sung dynasty	1127–1279	Ashikaga Yoshimitsu	1368–1394
Yüan dynasty	1279–1368	Ashikaga Yoshimasa	1449–1473
Ming dynasty	1368–1644	Momoyama period	1568–1615
Hsüan-tê	1426–1435	Oda Nobunaga	1573–1582
Ch'êng-hua	1465–1487	Toyotomi Hideyoshi	1586–1598
Hung-chih	1488–1505	Tokugawa Ieyasu	1600–1616
Chêng-tê	1506–1521	Edo (Tokugawa) period	1615–1868
Chia-ching	1522–1566	Genna-Kan'ei eras	1615–1643
Wan-li	1573–1619	Genroku era	1688–1703
T'ien-ch'i	1621–1627	Bunka-Bunsei eras	1804–1829
Ch'ung-chêng	1628–1644		
Ch'ing dynasty	1644–1912		

CATALOGUE

1 Jar with three feet
T'ang dynasty, 8th century
Yüeh ware
H. 8⅝ *in.* (21.9 *cm.*)
Kanzeon-ji, Fukuoka Prefecture

This jar was found at Ryumyoji in Dazaifu, Fukuoka Prefecture. The precise date and circumstances of the find are not known, but it is believed that the piece was recovered about 1940. The area of northern Kyushu served as the main entry route for Chinese trade from very early times and important finds of Chinese material, especially ceramic wares, have been made at the sites of the numerous temples and governmental centers established in this area over the centuries. The globular body with three feet in the shape of animal legs imitates a Chinese bronze vessel type called *fu*. This shape has not been found among other examples of the green-glazed stoneware known as Yüeh ware, but judging from the form, glaze, and potting techniques used, it is assumed that the jar was produced at a Yüeh ware kiln in China in the eighth century. Its dark glaze has acquired an iridescent hue due to long burial. On the unglazed, dark brown base, a number of spur marks indicate where the vessel was supported during firing. One of the three legs was damaged and has been repaired.

Ref.: Bibl. No. 21, vol. 30, pl. 54; No. 22, vol. 11, pl. 82; No. 47, pl. 21

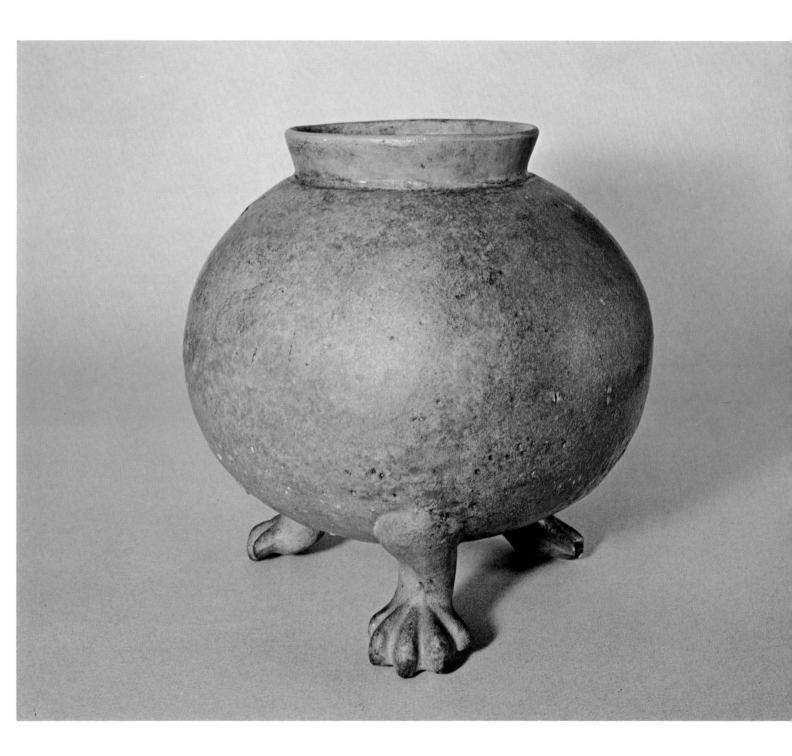

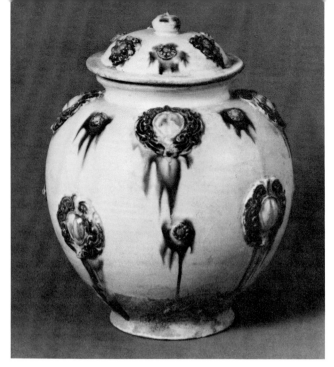

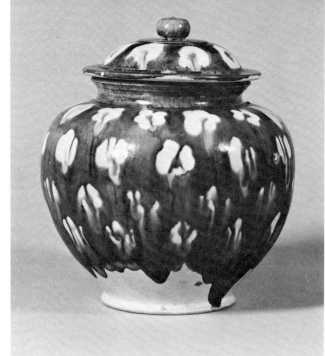

2 Jar and cover

T'ang dynasty, 8th century
Three-color ware
H. 9⅝ *in.* (24.5 *cm.*)
Seikadō Bunko Foundation, Tokyo
Important Cultural Property (frontispiece)

This covered jar with an almost spherical body is commonly termed a "ten thousand year jar" or "ten thousand year cereal jar" because jars of this type were filled with grain and interred with the deceased during the T'ang dynasty. The polished elegance of the type alone, however, might evoke such a promise of eternal richness and enduring beauty and strength. The foliate medallions that form relief decoration on the body and cover are accentuated by rich blue, yellowish brown, and green glazes. The device of applying such medallions became popular during the Sui and early T'ang dynasties. The motif was closely copied from Sasanian Persian designs as part of the vogue for exotic foreign fashions which prevailed in China at that time. The contrast between the glazes, which run over the relief decoration onto the white glazed body, offers a striking and attractive visual impact. Few of these spectacular jars have retained their covers, which makes this piece exceptional. In addition, the impressionistic use of three-color glaze and the superb form distinguish this as the preeminent jar of its type. It was probably made in Ch'ang-an or Lo-yang in the early eighth century. Three-color ware of this type is called *san-ts'ai* in Chinese, *sansai* in Japanese, and is distinguished by the use of a low-fired lead silicate glaze.

Ref.: Bibl. No. 19, vol. 1, pl. 49; No. 21, vol. 30, pl. 131; No. 22, vol. 11, pl. 48; No. 29, pl. 4; No. 32, vol. 9, pl. 1; No. 58, p. 370; No. 63, pl. 11

3 Jar and cover

T'ang dynasty, 8th century
Three-color ware
H. 9⅜ *in.* (23.8 *cm.*)
Tokyo National Museum; gift of Mr. Matsushige Hirota

This jar comes from the peak production period of T'ang three-color ware during the first half of the eighth century, when the T'ang dynasty reached the height of its international power and wealth. After the rebellion of General An Lu-shan in 755, however, the control of the central government was severely weakened and the production of three-color ware declined along with the fortunes of the T'ang Empire. This covered jar was acquired by a Japanese collector from China in the early part of this century. It has been selected for the exhibition even though it is not a handed-down piece, because this type of T'ang three-color ware exerted a strong influence on the native Japanese pottery industry in the Nara period. The emerald green, mustard yellow, and white glazes were cleverly applied to create flower patterns set horizontally in bands around the body of the jar and the cover. During the firing, however, the glazes flowed, particularly the mustard yellow glaze defining the centers of the flowers. This progressive loss of clarity in the delineation of the designs in the lower bands of blossoms on the jar results in an impressionistic design modern in feeling. Like the jar No. 2, this piece is among the finest known examples of T'ang covered jars with three-color glaze.

Ref.: Bibl. No. 22, vol. 11, pl. 50

4 Vase

T'ang dynasty, 8th century
Three-color ware
H. 10 *in.* (25.3 *cm.*)
Tokyo National Museum; gift of
Mr. Tamisuke Yokogawa

The precise transitions from the long narrow neck to the full, bulbous body and the high, flaring foot give this vase an elegant profile, classical in appeal. The shape derives from Persian metal prototypes and has retained the sharp, unmodeled contours characteristic of metal forms. The distinctive everted lip of the vessel is distinguished by its rather flat and compact form. Four floral medallions in relief decorate the body and just below the neck are tassel-like ornaments, also in relief. A three-color glaze of green, mustard yellow, and white creates a richly dappled pattern over the surface of the vessel. The flowing of the glazes around the wide, flaring lip has produced a petal-like design. A vase similar in shape, but executed in copper, was among the treasures from the Hōryū-ji presented in 1878 to the Imperial Household Collection, now part of the Tokyo National Museum collections. Related examples were also made in Yüeh celadon, *temmoku,* and white porcelain during the fifth and sixth centuries in China. Moreover, among the excavated T'ang three-color ware material from Okinoshima, an island off the coast of Kyushu, a vase similar to this one was found, suggesting that this type of three-color ware was being imported to Japan as early as the eighth century.

Ref.: Bibl. No. 22, vol. 11, pl. 43; No. 32, vol. 10, pl. 60; No. 62, vol. 1, pl. 35.

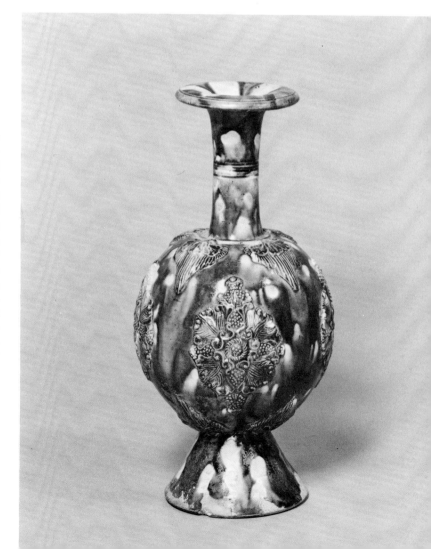

5 Group of fragments
T'ang dynasty, 8th century
Three-color ware and marbled ware
Agency for Cultural Affairs, Japan

The three-color ware fragments were excavated in 1966 from the
site of the main hall (*kondō*) of the Daian-ji, a temple in Nara dating
from the Tempyō period. More than two hundred pieces of three-
color pottery fragments were found under a level of burned earth
at the south side of the *kondō* and it is presumed that this pottery
was broken and buried at the time the *kondō* burned in the eighth
century. Included in the cache were ceramic pillow fragments and
remnants of a variety of other shapes. Because T'ang three-color
ware is rarely discovered outside China, these fragments provide
very important material for research into the cultural and com-
mercial ties between China and Japan in the Nara period.

The shards of marbled ware included here were discovered at
the same site. The ware, a type popular in China during the T'ang
period, was created by mixing together clays of different colors.

Ref.: Bibl. No. 22, vol. 11, pl. 237; No. 47, pls. 1, 2

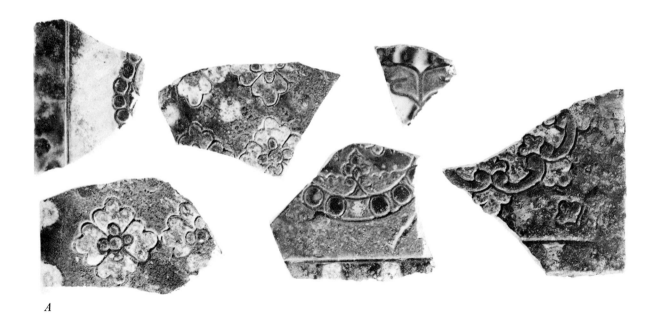

A

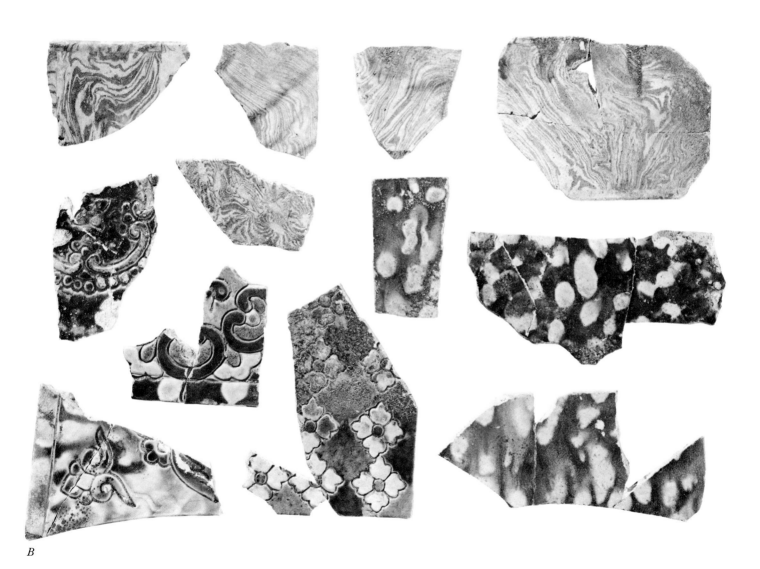

B

41

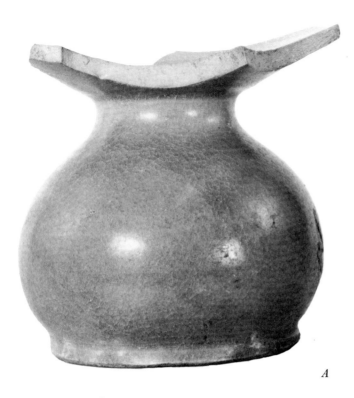

A

6　Group of fragments

T'ang dynasty, 9th–10th century
Celadon and white porcelain
Nara National Research Institute of Cultural Properties

A large number of Chinese ceramics were exported to Japan during the late T'ang and the Five Dynasties periods. Many have been excavated in Japan, especially in northern Kyushu at Dazaifu, a port of entry for the Chinese trade; on the grounds of a Heian period palace in Kyoto; and at the Heijō Palace site in Nara where these fragments were found. Most of the excavated celadon, or green-glazed, pieces of this period, chiefly tea bowls and bowls, are Yüeh ware. The damaged celadon spittoon included here is the only vessel of this shape so far excavated in Japan. It is as yet uncertain where in China the white porcelain fragments were produced. It is generally believed that they were made in the South although the thick lip and partly glazed base characteristic of these fragments show a close relationship to northern Ting ware. The excavation of the ancient Heijō Palace site of the Nara court is currently being conducted by the Nara National Research Institute of Cultural Properties and many more examples of T'ang ceramics are likely to come to light in the near future.

Ref.: Bibl. No. 47, pl. 8

B

43

7 Ewer

Sung dynasty, 10th–11th century
Yüeh ware
H. 8⅝ *in.* (21.8 *cm.*)
Kyoto National Museum

This ewer was excavated in 1937 at the site of the Jōmyō-ji, a Nara period temple near Uji, outside Kyoto. The prestigious Fujiwara family had close ties to the temple and the family cemetery is located nearby. From the ranks of this family were chosen the regents of the Imperial court, the virtual rulers of the country during much of the Heian period. As it was customary for families of wealth and power to make gifts of rare and precious objects to temples and shrines as an act of piety and the Fujiwaras owned many fine examples of Chinese ceramics, this ewer might even have been presented by them to the Jōmyō-ji. The ewer is believed to have been made at a Yüeh kiln, probably in the tenth century. A fragment of a similar ewer with an incised inscription containing a date corresponding to 1012 was excavated at a kiln site in the Yin Hsien district, Chekiang, near Ning-po, the port city known in ancient times as Ming-chou. Yüeh ware was greatly appreciated in medieval Japan and references to "blue ware" or "secret color ware" (Ch. *pi-se yao*) appear in contemporary literary works such as the *Tale of Genji* and in documents such as the records of the Ninna-ji in Kyoto which catalogue the temple collection. Recently many similar pieces have been excavated in China, enabling scholars to trace a stylistic development from the gently swelling bodies of the T'ang period to the more precise contours of ewers made during the Sung period. The most famous Yüeh ware kiln was located at Shang-lin-hu in northern Chekiang and many other Yüeh kilns were also located in the northeastern coastal area of Chekiang Province.

Ref.: Bibl. No. 8, pl. 306; No. 21, vol. 30, pl. 55; No. 22, vol. 11, pl. 149; No. 47, pl. 23

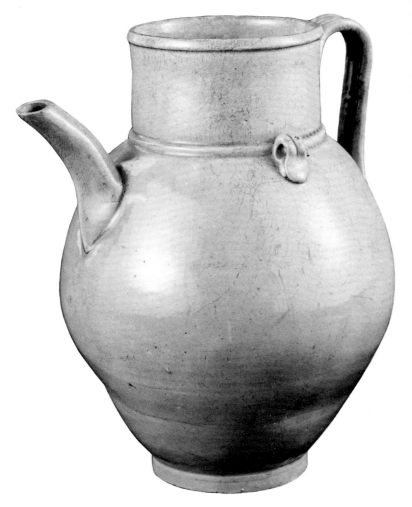

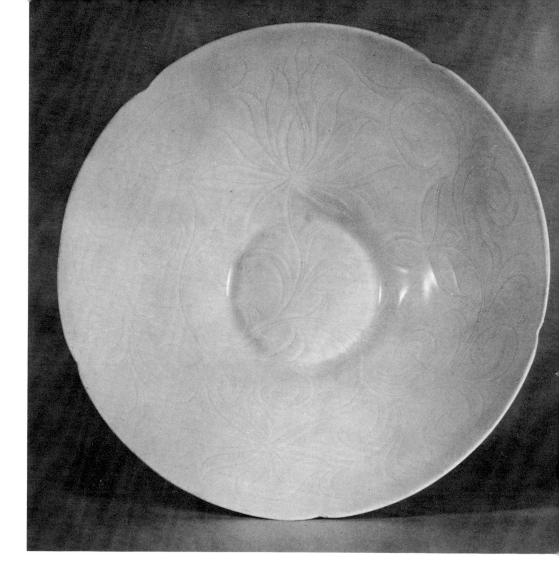

8 Bowl with foliate rim
Sung dynasty, 11th century
Ting ware
Diam. 9¾ in. (24.6 cm.)
Umezawa Memorial Museum, Tokyo
Important Cultural Property

This bowl has an angular, flared shape with a lightly foliate rim. The sharply incised carving is typical of Northern Sung Ting ware and the wide diameter of the foot and the deeply hollowed foot rim are characteristic features of early Northern Sung pieces. A typical ivory white glaze covers the body, partially running in "tear drops" on the outside of the bowl. The history of this particular piece in Japan is clouded, but examples of the celebrated Ting ware, which attained its greatest fame early in the twelfth century, were imported to Japan from the end of the Kamakura period and the ware is often mentioned in contemporary literature. No doubt this bowl was handed down from generation to generation as a priceless treasure, like the Ting ware bowl in the possession of the Maeda family of Kaga, Ishikawa Prefecture, which is regarded as the finest heirloom piece of its kind in Japan.

Ref.: Bibl. No. 8, pl. 280; No. 19, vol. 1, pl. 85; No. 29, pl. 48

45

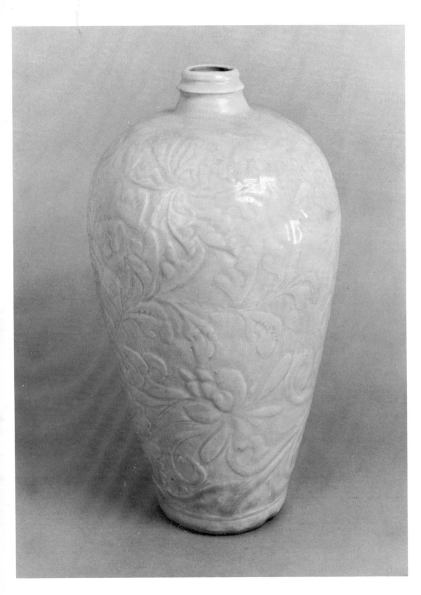

9 *Mei-p'ing* vase
Sung dynasty, 12*th*–13*th century*
Ch'ing-pai ware
H. 15 ⅛ *in.* (38.5 *cm.*)
Tokyo National Museum

This vase, which was found near Mito in Ibaraki Prefecture, is regarded as one of the finest examples of *ch'ing-pai* excavated in Japan. *Ch'ing-pai* (lit. bluish white) was produced in Kiangsi near Ching-tê-chên, which later, during the Ming and Ch'ing dynasties, was to become the ceramic capital of China. This piece is probably the largest *ch'ing-pai* vase of *mei-p'ing* shape in the world. The roughly carved design of lotus and peony flowers displays a bold vigor. The ribbed neck is a motif that was often copied by Japanese potters at the Seto kilns where a glazed stoneware influenced by wares of this type was produced during the Kamakura period. The glaze on this vase is transparent with a bluish tint; the base is unglazed and has burned slightly reddish. All these characteristics suggest that the vase was made at a kiln in South China around the twelfth or thirteenth century. Unfortunately, this piece was heavily damaged when it was found and the adhesive used to repair it has given the restored portions a yellowish discoloration.

Ref.: Bibl. No. 8, p. 240; No. 19, vol. 1, pl. 95; No. 21, vol. 30, pl. 56; No. 62, vol. 1, pl. 19

10 *Mei-p'ing* vase
 Sung dynasty, 12th–13th century
 Ch'ing-pai ware
 H. 11⅝ *in.* (29.5 cm.)
 Kyoto National Museum

This vase of *mei-p'ing* shape is said to have been excavated from the
site of the Hosshō-ji, a temple erected in the Heian period in Kyoto
at the command of Emperor Shirakawa (r. 1072–1086). Vases in
the *mei-p'ing* shape, with a tall, full body and small mouth, were
imported from China to Japan in great quantities beginning in the
thirteenth century. This style of *ch'ing-pai mei-p'ing* is seldom en-
countered in other parts of Asia, however, which suggests that the
Japanese had a particular fondness for the type. Some scholars
maintain that only the Ching-tê-chên kilns in Chekiang Province
produced this type of *ch'ing-pai* ware, but as some nineteen kilns in
maritime Fukien Province are also known to have manufactured
ch'ing-pai ware in the Sung period, it has been argued that many of
the vases found in Japan were produced at Fukien kilns. This vase
is vigorously decorated with a carved design of boys among floral
scrolls against a combed pattern ground. The comparatively large
scale of the figures and foliate scrolls, which are dramatically cut
out with a rather broad engraving tool, gives the vase an imposing
presence. A bluish white glaze spreads over the body, pooling in
rivulets in the carved design to create a mystical, shadowy surface
effect.

Ref.: Bibl. No. 47, pl. 32

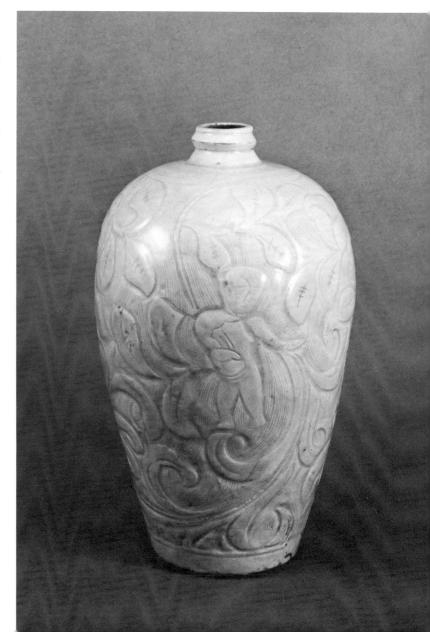

11 Sutra container and cover
Sung dynasty, 12th century
Ch'ing-pai ware
H. 9½ in. (24.1 cm.)
Tokyo National Museum

This sutra container was excavated in 1935 from a sutra mound on Kogo Island off Shikoku in the Inland Sea. It was found with two bronze mirrors of Japanese manufacture and two Chinese bronze mirrors. Although the transparent white glaze is slightly different from the typical *ch'ing-pai* glaze, the peony scroll design thinly carved on the body of the container is a common motif on Sung dynasty ceramics, and the lotus petal design on the cover is similar to the decoration on small covered Chinese jars recovered from sutra mounds dating to the twelfth century. The base is unglazed. A number of sutra containers of Chinese manufacture, in celadon glaze as well as in white porcelain, have been found at twelfth-century sutra mounds in Japan, and it is suspected that they were produced on special order, since this shape is rarely found in China itself.

Ref.: Bibl. No. 8, pl. 312; No. 32, vol. 10, pl. 217; No. 47, pl. 47

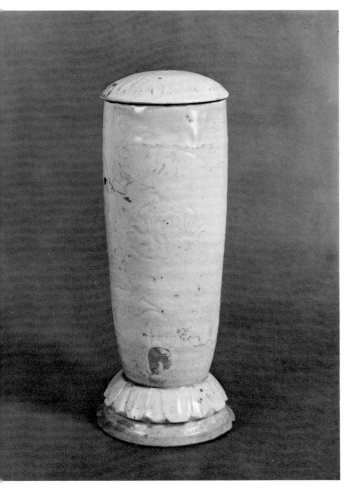

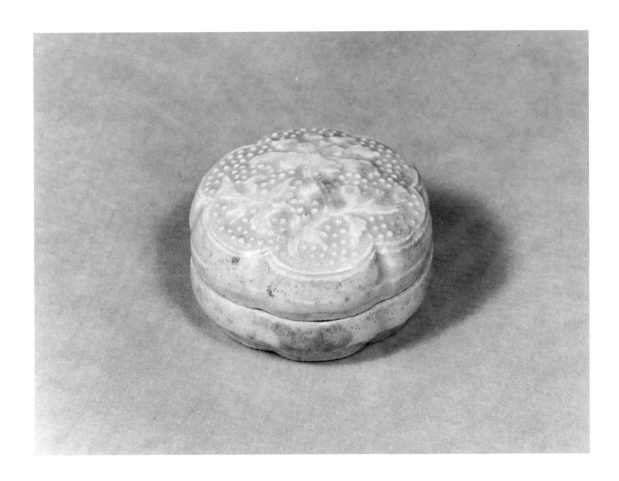

12 Box and cover

Sung dynasty, 12th century
Ch'ing-pai ware
H. 1⅝ *in.* (4.2 *cm.*); *Diam.* 3 *in.* (7.4 *cm.*)
Itsukushima Shrine, Hiroshima Prefecture

This small covered box (J. *gosu*) was excavated at Itsukushima Shrine in Hiroshima Prefecture. Located on an island, the shrine is known throughout the world for its famous gateway (*torii*), which rises majestically from the waters of the Inland Sea. During the late Heian period, Itsukushima was the family shrine of the Taira, a samurai clan who gained political dominance in the twelfth century after a series of decisive battles and complicated political intrigues. The Taira family made many offerings to this shrine, among them the set of important decorated sutra scrolls known as the *Heike Nōkyō*, and although there is no definite proof, this covered box might well have been donated to the shrine by a member of the family. Inside the box are three small dishes and a bud-shaped ornament; a floral spray in relief is delicately arranged on the top of the cover. More than one hundred covered boxes of *ch'ing-pai* have been excavated from sutra mounds in Japan, but few can equal the qualities of glaze and design of this piece. The earliest dated sutra mound where *ch'ing-pai* has been found dates from 1120. The greatest number of pieces of *ch'ing-pai* ware, however, have been excavated from sites of the second half of the twelfth century, indicating that this was the peak period for the importation of these wares.

Ref.: Bibl. No. 8, pl. 317; No. 21, vol. 30, pl. 3; No. 47, pl. 53

49

13 Group of eight covered boxes

Sung dynasty, 12th century
Ch'ing-pai ware
(*A*) *L: Diam. 2¼ in. (5.6 cm.)*
 R: Diam. 2 in. (5.0 cm.)
(*B*) *L: Diam. 2⅜ in. (5.8 cm.)*
 R: Diam. 1¾ in. (4.5 cm.)
(*C*) *L: Diam. 2⅜ in. (5.9 cm.)*
 R: Diam. 2⅜ in. (5.8 cm.)
(*D*) *L: Diam. 2⅛ in. (5.2 cm.)*
 R: Diam. 2¼ in. (5.5 cm.)
Tokyo National Museum

Three twelfth-century sutra mounds were excavated at Kami-akitsu, Tanabe city, in Wakayama Prefecture in 1931, yielding nineteen pieces of *ch'ing-pai* ware. This group of *ch'ing-pai* covered boxes was selected from the Kamiakitsu hoard. Formed from molds, small covered boxes such as these were probably mass-produced at kilns at P'u-ch'êng in northern Fukien Province. The floral designs on the covers vary, and rarely do two have the same composition, indicating that a number of different molds were in use at the P'u-ch'êng potteries. Great quantities of these covered boxes were brought from China to Japan and Korea, but they do not seem to have been exported to Southeast Asian countries.

Ref.: Bibl. No. 47, pls. 74, 75

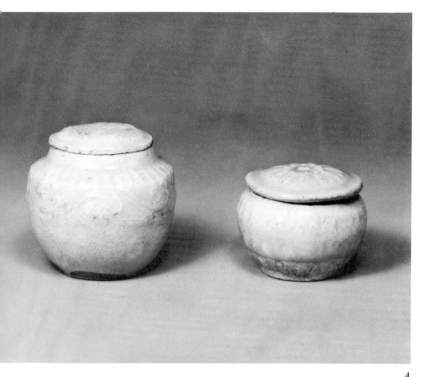

A

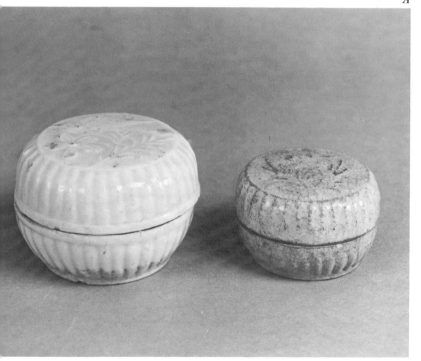

B

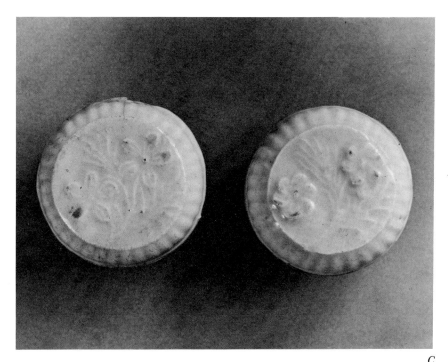

C

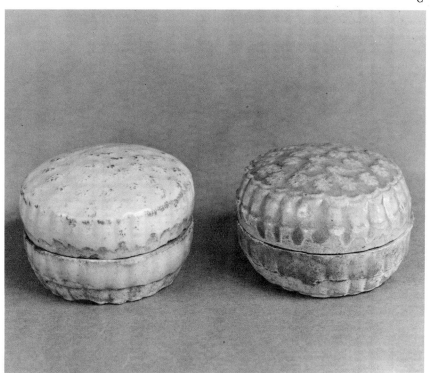

D

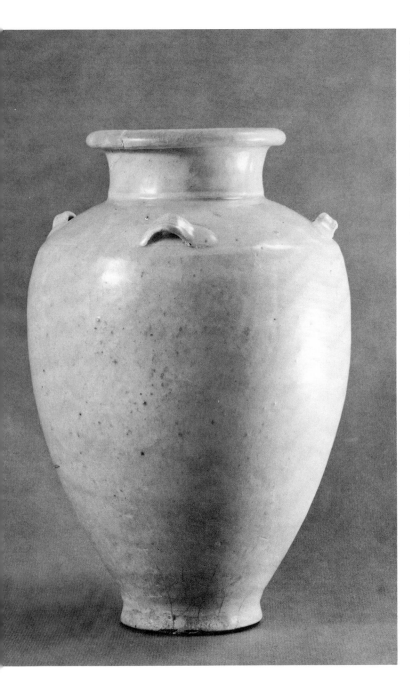

14 Jar with four handles

Sung dynasty, 12th–13th century
Ch'ing-pai ware
H. 11 *in.* (27.9 *cm.*)
Kyoto National Museum

Although such pieces are rarely excavated in China, Korea, or Southeast Asia, four-handled vases or jars with *ch'ing-pai* glaze are a type frequently found in Japan. Further evidence of the popularity of this type in Japan is the fact that these vases exerted a profound influence on wares produced at the Japanese Seto kilns in the Kamakura and early Muromachi periods. Although this vase is said to have been found at Narasaka in the city of Nara, the date of its discovery is unknown. Because the *ch'ing-pai* glaze is tinted slightly bluish and is matte in appearance, it seems likely that the jar was produced at a kiln in Fukien Province. Its wide shoulder and flared foot suggest that it was manufactured in the late twelfth or early thirteenth century. Except for a small chip at the mouth, the jar is in virtually perfect condition.

Ref.: Bibl. No. 47, p. 101

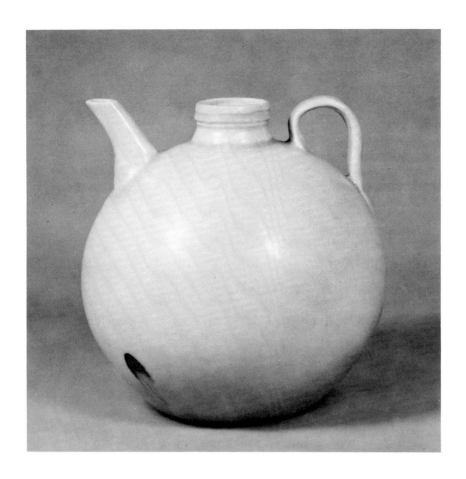

15 Ewer

Sung dynasty, 12th–13th century
Ch'ing-pai ware
H. 6⅝ *in. (16.6 cm.)*
Tokyo National Museum

According to tradition, this ewer was excavated in 1918 from the temple precincts of the Kanzeon-ji in Fukuoka Prefecture, Kyushu. Reportedly it was found buried together with a celadon incense burner, a celadon vase, and a bronze bowl, but the circumstances of the excavation are not clear and there is no way to document this. Although excavated ceramics are usually heavily damaged, this piece was discovered in nearly perfect condition. Only a few small chips, now restored, can be detected on the spout and handle. The spherical white clay body is covered with a blue tinted glaze, whose delicate color is emphasized by the accidental splash of iron brown caused by an impurity in the glaze material. As ewers of similar shape are known to exist in private collections in Japan and as the shape was copied by Japanese potters at Seto, there is no doubt that ewers of this type were imported from China in great numbers in the late Heian and early Kamakura periods. This piece was probably produced at a kiln in South China in the twelfth century.

Ref.: Bibl. No. 8, pl. 310; No. 19, vol. 1, pl. 96; No. 21, vol. 30, pl. 5; No. 32, vol. 10, pl. 89; No. 47, pl. 27; No. 62, vol. 1, pl. 20

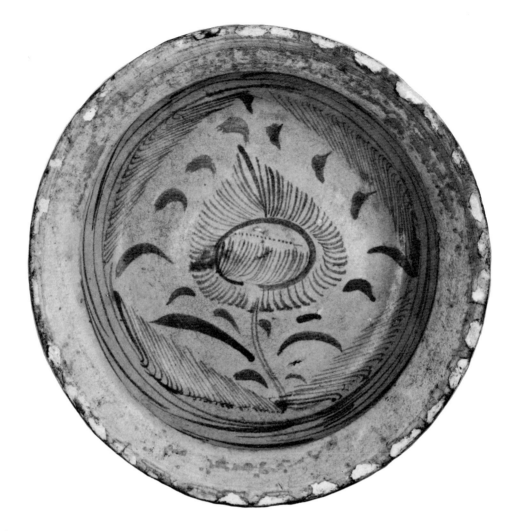

16 Dish with a broad rim

Sung dynasty, 12th century
Iron brown decorated ware
Diam. 14⅜ in. (36.5 cm.)
Fukuoka City Museum of Historical Material

In the spring of 1975 this dish was excavated from a sutra mound at Tajima, Fukuoka city. Because it was found together with a small covered box in *ch'ing-pai* glaze of a type commonly excavated at twelfth-century sites, it has been assumed that the dish dates from around the first half of the twelfth century. It was made with coarse, but lightweight, clay and the surfaces were coated with a white slip. A floral design painted in iron brown pigment under a yellowish brown celadon type glaze decorates the piece. Wares with this type of glaze and iron brown decoration were produced at the Shang-sha kilns in Honan Province during the late T'ang period, and a few examples from the Yüeh kilns are known as well. Large spur marks, which show where spurs supported the vessel inside a sagger during firing, can be seen on the outer edge of the wide rim.

Ref.: Bibl. No. 47, pl. 34

17 Dish with incised peony design
Sung dynasty, 12*th–*13*th century*
Three-color ware
Diam. 14⅝ *in.* (37.1 *cm.*)
Daigo-ji, Kyoto

This unique dish provides important evidence of the production of three-color glazed wares in southern China during the Sung period. It has long been in the possession of the Daigo-ji in Kyoto, where it was used as a sacred vessel in a secret rain ceremony. The dish has a large flat base and gently curving sides. A grayish white slip was applied over the lightweight body and in the center a spray of peony flowers was crisply incised into the surface. Al-though this large dish is considered an example of three-color ware, actually glazes of only two different colors have been used: a yellowish brown freely brushed over the incised flowers and cavetto and a glossy forest green serving as a background. The stylistic characteristics of this piece suggest that it was created at a kiln in South China during the twelfth or the thirteenth century.

18 Vase

Sung dynasty, 12th–13th century
Kuan type celadon
H. 9⅛ *in.* (23.2 cm.)
Private collection
National Treasure

Kuan ware was produced for imperial use in China. Few examples were exported, however, and consequently Kuan celadons are highly prized in Japan. The design and execution of this Kuan type vase are exceptional. Its compact spherical body provides firm support for the thrust of the long neck which ends in a neatly flared lip. The low, broad foot has also been worked with great care. This particular shape is known in Japanese as *shimokabura*, or "turnip" shape, a term obviously prompted by the rounded body form. A thick coating of light blue green glaze spreads smoothly and richly over the grayish white body, resembling the luster of polished jade. This glaze, combined with the superb potting and form, make this piece one of the finest examples of Sung celadon in Japan. It is distinct from typical *kinuta* celadons (No. 22) in both glaze type and color. The vase was probably produced at the Southern Sung kiln of Hsiu-nei-ssŭ, as it is similar to fragments excavated at the site of that kiln by Tsuneo Yonaiyama. Although its history in Japan is somewhat uncertain, it is thought to be a piece which has been reverently treasured and passed down from generation to generation.

Ref.: Bibl. No. 19, vol. 1, pl. 112; No. 21, vol. 30, pl. 10; No. 32, vol. 10, pl. 15; No. 58, pl. 424; No. 63, pl. 56

19 Vase

Sung dynasty, 12th–13th century
Kuan type celadon
H. 9⅛ in. (23.1 cm.)
Idemitsu Art Gallery, Tokyo

Vessels decorated with ribbed patterns in relief are usually designated as the *takenoko* (bamboo shoot) type in Japan. Because the ribs on this vase are not pronounced, however, it has been traditionally classified according to its *shimokabura* (turnip) shape along with similar round-bodied wares (see No. 18). Most of the Southern Sung dynasty celadon imported to Japan was of the *kinuta* type produced at the Lung-ch'üan kilns (see No. 22), and included among these were many *shimokabura* vases. This piece, however, is slightly different from *kinuta* celadon, for its glaze, opaque and roughly crackled, is pale blue rather than the sea green typical of *kinuta* celadon glaze. It is presumed to be one of the few examples of Kuan celadon which exist in Japan. The fine articulation and clear-cut profile provide an impressive character to this spectacular vase and the dignified, majestic feeling of the piece is in accord with imperial rather than common usage. The vase is thought to have been made at the Chiao-t'an (Suburban Altar) kiln. It is not clear when this vase was brought to Japan, but it is no doubt one of the finest *densei* celadon pieces in existence. At one time it was in the famous ceramic collection of the Kōnoike family in Osaka; recently it was acquired by the Idemitsu Art Gallery, Tokyo.

21 Vase in the shape of a *tsun*
Sung dynasty, 12th–13th century
Lung-ch'üan celadon
H. 10⅝ in. (27.0 cm.)
Egawa Museum of Art, Hyogo Prefecture (below)

The trumpet-like mouth, the swelling body decorated with applied animal masks, and the high, flaring foot of this vase derive from an ancient Chinese bronze ritual vessel of the type known as a *tsun*. The ribbed decoration, also typical of bronze forms, is evocatively described in Japanese as *sasage-tsuru* (string bean tendrils) in an inscription on the wooden storage box, which appears to have been made for this vase in the Momoyama period. The grayish pottery body is thickly covered with a celadon glaze recalling the texture of jade. Some rough cracks can be detected on the lower part of the body. While it is not clear whether this vase was produced at a Kuan ware or Lung-ch'üan kiln, it is certainly among the finest extant Southern Sung celadons. It is also the only known *densei* celadon vase of *tsun* shape in Japan. As a *densei-hin*, this vase was treasured for many generations by the Mōri family of Yamaguchi Prefecture. The Mōri were a great daimyo family in western Honshu.

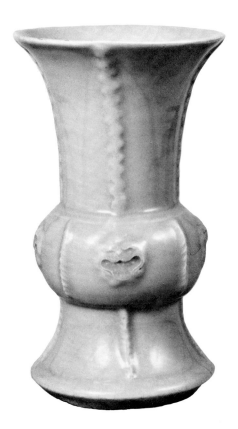

23 Vase
Sung dynasty, 12th–13th century
Lung-ch'üan celadon
H. 6⅝ in. (16.8 cm.)
Private collection (above)

This thinly potted cylindrical vase with slightly flared sides has a glaze lighter in color than *kinuta* celadon (see No. 22). The light crackle moving over the surface may follow strains made on the body when the vase was turned on a potter's wheel. Although it is not visible in this photograph, a small iron ring has been attached below the mouth to adapt the piece for use as a hanging flower vase in a tea ceremony room. Such hanging vases became fashionable in the Muromachi period. At one time this vase was in the possession of Takeno Jōō (1502–1555), a famous tea master and arbiter of taste in the Momoyama period. Later it was owned by the powerful warlord Toyotomi Hideyoshi (1536–1598), who unified the country in the late sixteenth century. The relationship between this Lung-ch'üan vase and its two illustrious owners is recorded in the tea ceremony memorandum of Yamanoue Sōji (1544–1590). Sometime in the Edo period, the vase entered the collection of the Mitsui family. A similar piece, slightly larger in size, is the famous vase owned by the Ōuchi family in Yamaguchi Prefecture now in the Nezu Art Museum, Tokyo (see Bibl. no. 45, p. 78, no. 162). A third, related vase is in the National Palace Museum, Taipei.

Ref.: Bibl. No. 8, pl. 192; No. 19, vol. 1, pl. 130; No. 21, vol. 30, pl. 17; No. 32, vol. 10, pl. 38; No. 58, pl. 425; No. 62, vol. 1, pl. 22

20 Water jar (*mizusashi*)
Sung dynasty, 12th–13th century
Kuan type celadon
H. 7¾ in. (19.7 cm.)
Tokyo National Museum

The *mizusashi* is a vessel for containing water used in the prepara-
tion of tea during the formal tea ceremony. Because it enjoys a
prominent position among the utensils used in the ceremony, a
superbly shaped vessel was required and impressive, sometimes
curious, pieces were favored. In form this *mizusashi* imitates a Chi-
nese jade *ts'ung*, an ancient jade ritual object identified with the
earth. It is called *sangi-de* in Japan, because the rectangular shape
with notched edges resembles wooden blocks used in fortune telling
(*sangi*). In the Sung dynasty, archaic bronzes and jades were ex-
ceedingly popular among antiquarians, and contemporary copies
were often made in celadon. The grayish body of this piece is cov-
ered with a thick, luminous celadon glaze that has a network of
large and small crackle. Three characters are incised on the base,
but unfortunately the meaning of the inscription is not clear. This
vessel was probably originally intended to be a flower vase. In
Japan, however, it was adapted for use in the tea ceremony. Before
it was added to the Tokyo National Museum collections, the jar
was in the possession of the Date family of Iwate Prefecture for
many generations and must have been imported into Japan in the
middle of the Muromachi period. Similar pieces are in the collec-
tions of the National Palace Museum in Taiwan and the Percival
David Foundation in London.

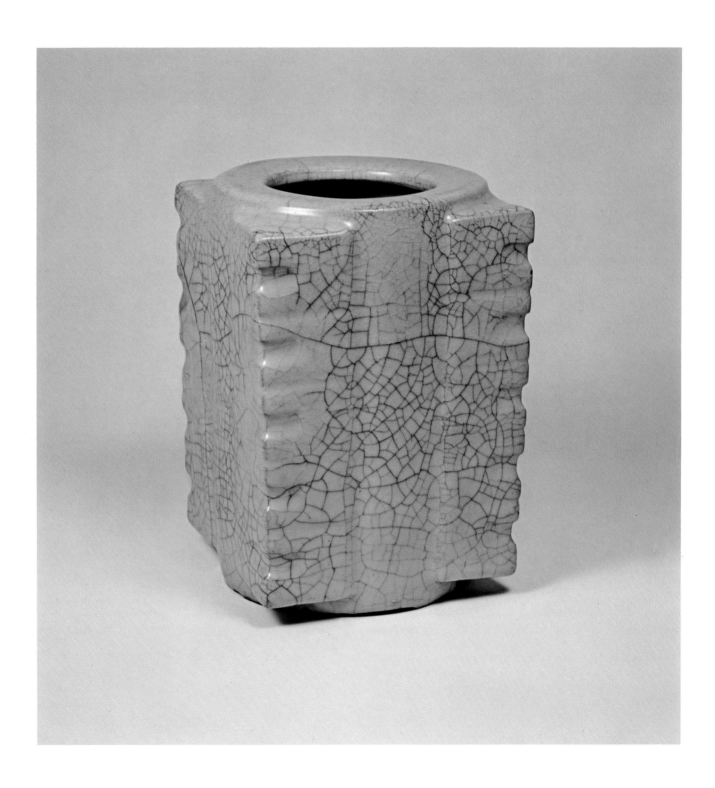

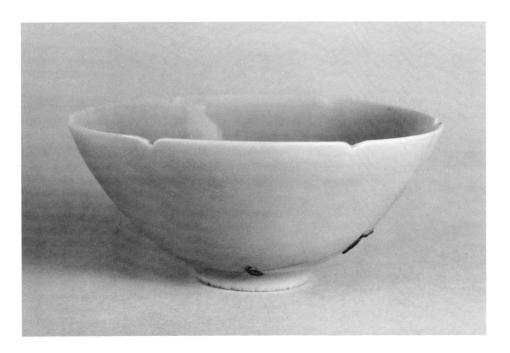

24 Tea bowl, named *Bakō-han*

Sung dynasty, 12th–13th century
Lung-ch'üan celadon
Diam. 6⅛ in. (15.4 cm.)
Tokyo National Museum; gift of Mr. Takahiro Mitsui
Important Cultural Property (color illus. p. 19)

This bowl may well have the longest history of any example of Southern Sung celadon passed down from generation to generation in Japan. According to a memorandum which accompanies the piece, it was originally given to Taira Shigemori in 1175 by a Chinese priest in gratitude for Shigemori's donation of gold to the priest's temple, the Huang Wang-shan in Chekiang Province. Later, the bowl entered the collection of Yoshimasa, the eighth Ashikaga shogun (1435–1490), who had it sent to China to be replaced by a similar piece because the base was broken. However, as such high quality celadon could no longer be made in China at that time, the original bowl was repaired with iron clamps and returned to Japan. Because the clamps (*han*) resembled the shape of a locust, the bowl was named *Bakō-han* (Large Locust Clamp). While the traditional history of this piece prior to its appearance in Yoshimasa's collection is questionable, the piece was probably created in the second half of the twelfth century, a date which accords both with the peak period of production at the Lung-ch'üan kilns during the Sung dynasty and with the supposed presentation in 1175 to Taira Shigemori. Later Yoshimasa presented the bowl to his attendant Yoshida Sōrin, who, in turn, handed it down to his descendants in the Suminokura family in Kyoto. Itō Tōgai, a ninth generation descendant of Sōrin, wrote the above-mentioned memorandum in the eighteenth century. After the Meiji Restoration in 1868, the bowl came into the possession of the Mitsui family and in 1970, according to the wish of the late Takahiro Mitsui, it was given to the Tokyo National Museum.

Ref.: Bibl. No. 8, pl. 195; No. 19, vol. 1, pl. 124; No. 21, vol. 30, pls. 6, 7; No. 32, vol. 7, pl. 22; No. 58, p. 428; No. 62, vol. 1, pl. 24

25 Incense burner

Sung dynasty, 12th–13th century
Lung-ch'üan celadon
H. 4⅜ *in.* (11.1 *cm.*); *Diam.* 5¾ *in.* (14.5 *cm.*)
Idemitsu Art Gallery, Tokyo

This celadon incense burner imitates the shape of a Chinese bronze *li*. In Japan, this shape with its three thick legs was called *hakama-goshi*, because it suggested the profile of a man wearing *hakama*, a type of Japanese men's divided skirt. This is one of the finest *densei* incense burners in the *hakama-goshi* shape, and the light bluish green glaze is a typical example of the *kinuta* celadon color. Many similar pieces are known in Japan, most of them with covers of metal mesh designed to facilitate their use as incense burners. This piece was in the collection of the Kondō family of Owari, now Aichi Prefecture, from the Edo period on. A large number of celadons of this type, produced at a Lung-ch'üan kiln towards the end of the Southern Sung period, were exported to Japan in the Kamakura period.

Ref.: Bibl. No. 27, cat. nos. 54, 95

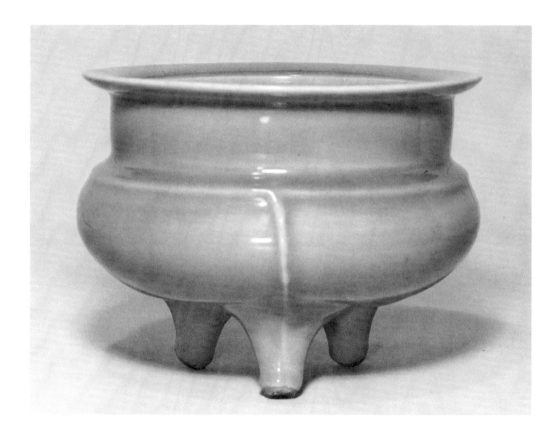

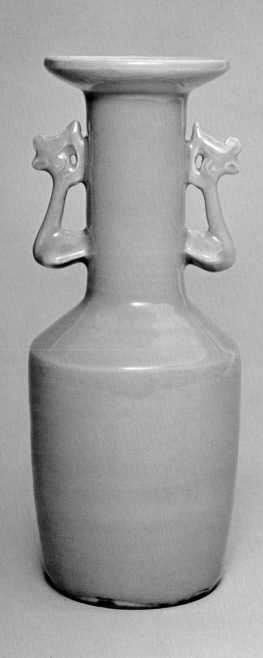

22 Vase with phoenix handles

Sung dynasty, 12th–13th century
Lung-ch'üan celadon
H. 11½ *in. (29.0 cm.)*
Hatakeyama Memorial Museum, Tokyo

The shape of this type of bluish green Lung-ch'üan celadon vase gave rise in Japan to the appellation *kinuta seiji* (mallet shaped celadon) as a generic term for celadons of this color. It is not known when this vase was imported to Japan, but it was probably brought over sometime in the Muromachi period, for it was known in the mid-fifteenth century. In the seventeenth century it belonged to Tōfukumon-in, the wife of Emperor Gomizuno-o (r. 1611–1629), who presented it in 1676 to Doi Noto-no-kami, a government official in Kyoto. It remained in the possession of the Doi family until a few years ago when it was purchased by the Hatakeyama Memorial Museum, Tokyo. This is the first time it has been shown in a public exhibition. A fragment of a similar piece with phoenix handles was excavated from a kiln site at Ta-yao, in the Lung-ch'üan district, and this piece is therefore thought to have been produced at a Lung-ch'üan kiln in the Southern Sung period.

A number of similar vases with phoenix handles are known in Japan. The most famous one was brought to Japan sometime in the thirteenth or fourteenth century and was named *Ban-sei* (Ten Thousand Voices) by Emperor Gosai (r. 1656–1663). It is preserved in the Bishamondō in Kyoto.

Ref.: Bibl. No. 19, vol. 1, pl. 120; No. 63, pl. 59

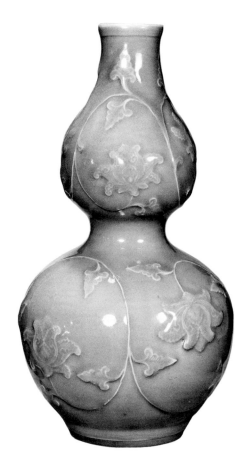

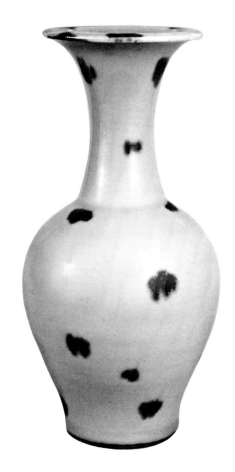

26 Double-gourd shaped bottle
Sung dynasty, 13th century
Lung-ch'üan celadon
H. 13⅛ *in.* (33.3 *cm.*)
Hatakeyama Memorial Museum, Tokyo

Only a small number of gourd shaped bottles in *kinuta* celadon are known. Among the few *densei* bottles of this type that exist in Japan, this is the largest and one of the most spectacular examples. The decoration of applied peony motifs, known in Japan as *uki botan* (floating peony), is commonly found on *kinuta* celadons. The peonies and vine tendrils are gently molded and carefully arranged on the rounded body of the vase above the shallow foot. The light blue green celadon glaze is glossy in appearance. This bottle is believed to have been made at the Lung-ch'üan kilns in the late Southern Sung dynasty. Long in the possession of the Tokugawa family in Kishu (modern Wakayama Prefecture), it was purchased by Kuzukiyo Hatakeyama in the twentieth century and later incorporated into the memorial museum which houses his personal collection.

Ref.: Bibl. No. 8, pl. 202; No. 19, vol. 1, pl. 121; No. 32, vol. 7, pl. 107

27 Vase
Yüan dynasty, 13th–14th century
Lung-ch'üan celadon
H. 10¾ *in.* (27.2 *cm.*)
Private collection
Important Cultural Property

Celadon with a rust brown dappled pattern formed by iron spots under the glaze is called *tobi seiji* (spotted celadon) in Japan. This type of greenish blue celadon glaze is presumed to have been the ancestor of Lung-ch'üan celadon of the *Tenryū-ji* type (see No. 44). The everted mouth and rounded shoulders of the vase are unusual. The irregular distribution of the iron spots seems unplanned, yet creates a striking decorative pattern. Celadon with iron spots is usually thought to be of Yüan manufacture, but some examples, as illustrated by this piece, retain the simple elegance and subtle contours of Sung wares. According to tradition, this vase was in the possession of the Kuroda family in Fukuoka Prefecture.

28 Octagonal jar

Yüan dynasty, 13th–14th century
Lung-ch'üan celadon
H. 9½ in. (24.1 cm.)
Private collection

This octagonal jar was decorated with a molded relief design of the eight legendary Chinese sages in the central section (see also No. 54) and with floral designs in relief around the shoulder and lower body. A thick celadon glaze covers the jar except for the eight figural panels, which were left unglazed. Fired a dark red, the designs in the panels are clearly visible. Iron brown spots which serve to accent the pictorial medallions were applied outside the four corners of each biscuit panel under the celadon glaze. Such a rich decorative style with iron spot accents is not found on celadon of the Sung dynasty. The form, decorative style, and glaze color of this piece clearly suggest a Yüan date. There are several *densei*

examples of iron spotted celadon (*tobi seiji*) in Japan (see No. 27), though examples with biscuit panels are rare. An octagonal jar with iron spot decoration and relief biscuit decoration now in the collection of the Percival David Foundation, London, is said to have been a *densei* piece in Japan. The jar shown here is regarded as one of the finest examples of its type and has a proud history. At one time it was in the possession of Agata Sōchi (1656–1721), who was an accomplished tea master and the *oniwagata* (official garden designer) of the Tokugawa shogun's family.

Ref.: Bibl. No. 8, pl. 207

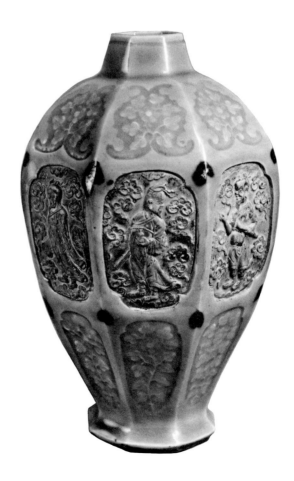

29 Two bowls and a dish

Sung–Yüan dynasty, 12th–13th century
Lung-ch'üan celadon
(A) Diam. 5⅜ in. (13.6 cm.)
(B) Diam. 5⅜ in. (13.5 cm.)
(C) Diam. 6¾ in. (17.0 cm.)
Agency for Cultural Affairs, Japan

These three celadon pieces were excavated at Izumo in Shimane Prefecture in the 1960's. They were found inside a large Tokoname ware jar of a style typical of the Kamakura and Muromachi periods. The circumstances of their burial account for their having survived in superb condition. The outer sides of the two bowls are carved with a lotus petal design and a thick greenish celadon glaze covers the surfaces. Lotus petals are also carved on the interior of the dish, which has a stamped floral design in its center; the piece is covered with a powdery blue celadon glaze. All three are Lung-ch'üan celadon of the kind manufactured during the Southern Sung dynasty, the most prevalent type of celadon excavated in Japan. The production of Lung-ch'üan celadon continued into the Yüan dynasty as well and these pieces are thought to date sometime between the Sung and Yüan dynasties.

Ref.: Bibl. No. 47, pls. 133, 134

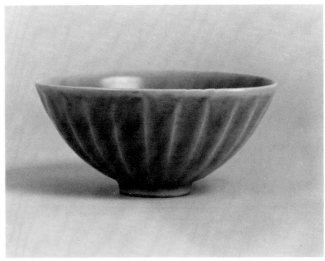

A

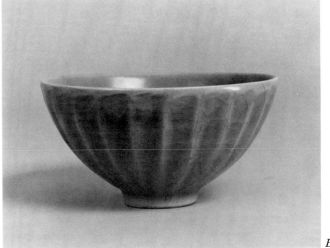

B

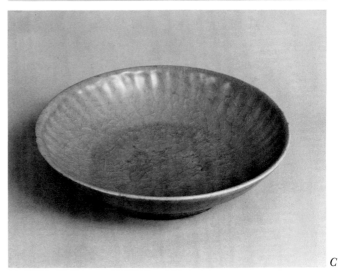

C

30 Three bowls

Sung–Yüan dynasty, 12th–13th century
Lung-ch'üan celadon
(A) Diam. 8¾ *in.* (22.3 *cm.*)
(B) Diam. 8⅝ *in.* (22.0 *cm.*)
(C) Diam. 15⅞ *in.* (40.3 *cm.*)
Tokyo National Museum

Chinese celadon of the late Sung and early Yüan periods was the ware most frequently imported and most highly prized by the Japanese. Although the majority of the Chinese celadons imported to Japan were of the Lung-ch'üan type, the Japanese divided them into several categories. Pieces imported in the twelfth and thirteenth centuries were called *kinuta* celadon (see No. 22), those brought over in the fourteenth and first half of the fifteenth century were, as a rule, called *Tenryū-ji* celadon, and those of the sixteenth century and after were called *shichikan* celadon.

In the thirteenth century many Chinese ceramic wares entered Japan through the port of Kamakura and these three celadon pieces were excavated in Kamakura at Kinubari-yama in the 1950's. The two smaller bowls were fitted together to form a container which was used as a cinerary urn. This in turn was placed on the large bowl. The smaller bowls are decorated with a deeply carved lotus petal design and have a translucent blue green glaze typical of *kinuta* celadon. On the interior of the large bowl is a carved design of floral motifs inside lotus petal panels; in the center of the bowl there is an applied chrysanthemum flower medallion. Carved floral scrolls ornament the exterior and the bowl has a glaze typical of *Tenryū-ji* type celadon (see No. 44). The combination of *kinuta* and *Tenryū-ji* type celadons from a Kamakura period (1185–1333) site suggests that these pieces were imported to Japan between the late Sung and early Yüan periods.

Ref.: Bibl. No. 8, pl. 308; No. 47, pls. 156, 157

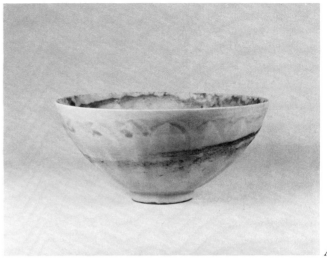

A

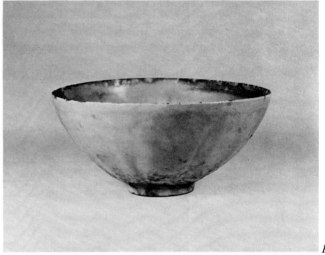

B

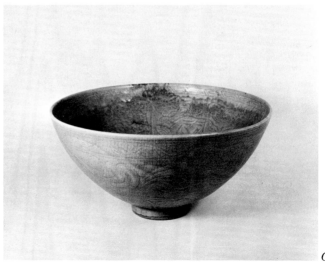

C

31 Ten bowls and dishes

Sung–Yüan dynasty, 12th–13th century
Celadon and white porcelain
(A) *Diam. 6¾ in. (17.0 cm.)*
(B) *Diam. 6½ in. (16.5 cm.)*
(C) *Diam. 6⅝ in. (16.9 cm.)*
(D) *Diam. 5¼ in. (13.2 cm.)*
(E) *Diam. 6⅝ in. (16.8 cm.)*
(F) *Diam. 3¼ in. (8.3 cm.)*
(G) *Diam. 6¼ in. (15.9 cm.)*
(H) *Diam. 6¾ in. (17.2 cm.)*
(I) *Diam. 6½ in. (16.4 cm.)*
(J) *Diam. 3¾ in. (9.3 cm.)*
Private collection

The celadon and white porcelain bowls and dishes in this group were found in the 1950's, at a site which appears to have been a tomb, in Imazu, Fukuoka city. More than 120 pieces, which range in glaze color from fine quality sea blue *kinuta* celadon to a coarse yellowish celadon, were discovered at the site. Thus, it seems that quantities of various types of celadon were imported concurrently to Japan from the twelfth through the fourteenth centuries. Since the time of their introduction to Japan, superb quality celadon ceramics have been avidly collected and admired by the Japanese and, as a result, a number of choice examples have been preserved to the present day. Examples of white porcelain, however, were rarely kept as *densei* pieces. Most of these celadons and white porcelains were produced at kilns at Lung-ch'üan in Chekiang Province or in Fukien Province during the Southern Sung and Yüan dynasties.

Ref.: Bibl. No. 47, pls. 114–118

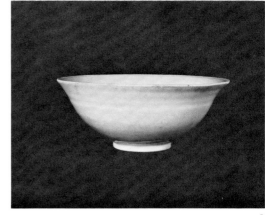

G

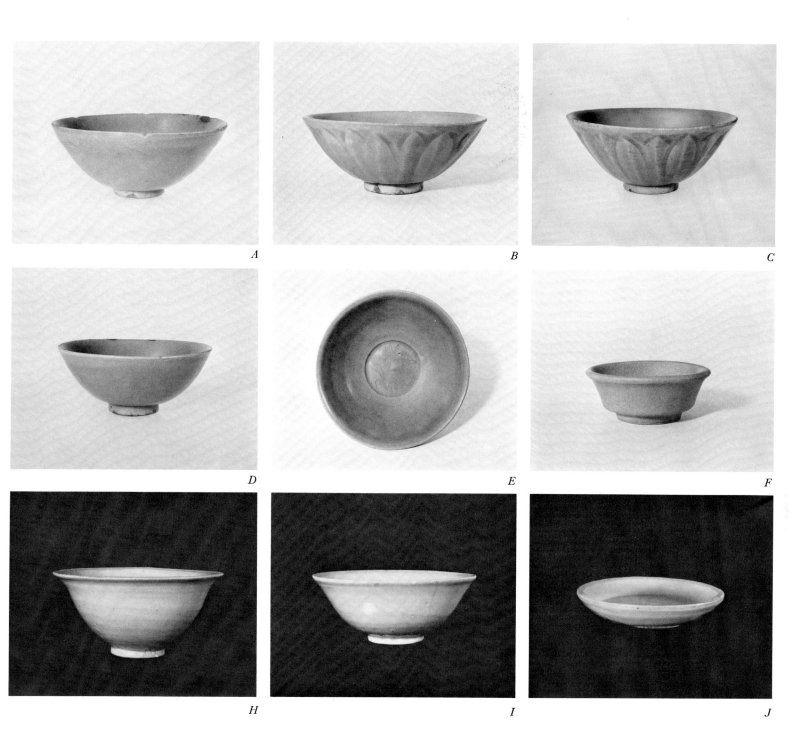

A B C

D E F

H I J

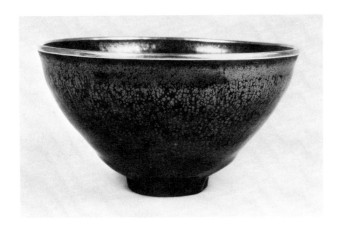

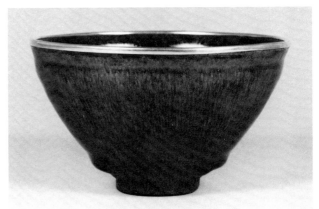

32 Tea bowl

Sung dynasty, 12th–13th century
Chien ware, oil spot temmoku
H. 2¾ in. (6.8 cm.); Diam. 5 in. (12.5 cm.)
Private collection
Important Cultural Property

In Japan the type of lustrous black iron glaze seen on this tea bowl is known as *temmoku*. *Temmoku* is the Japanese pronounciation of T'ien Mu, the name of a mountain temple site in Chekiang Province where Japanese Zen monks of the Kamakura period found bowls such as this one in use. Beginning in the thirteenth century, large numbers of *temmoku* tea bowls from the Chien ware kilns in Fukien Province were imported to Japan and by the fifteenth century, a distinct taste for fine bowls of this type had developed. In the catalogue of the treasures belonging to Yoshimasa, the eighth Ashikaga shogun (1435–1490), many *temmoku* tea bowls are recorded. According to the standards of connoisseurship of *temmoku* ware in Japan outlined in this record, the most prized type was *yōhen temmoku* (iridescent glaze *temmoku*) of which only three pieces are known to exist today. Second in importance was *yuteki temmoku* (oil spot *temmoku*). Only about ten first quality *densei* examples of oil spot *temmoku* have been preserved in Japan, and this bowl is one of the finest. It displays a noble, elegant profile. The dark clay body, typical of Chien ware, is beautifully draped with a glossy black glaze speckled with silvery spots. The bowl was most likely imported to Japan at the end of the Muromachi period, but its history is unclear until the Momoyama period when Furuta Oribe, a prominent tea master, owned it. Later, the bowl belonged to Doi Toshikatsu, a regent of the Tokugawa government, and then appeared in the collection of the Kinoshita family, the daimyo of Bungo (modern Oita Prefecture). In the late Edo period the bowl came into the possession of the noted tea master and author, Matsudaira Fumai (see also Nos. 36, 44).

Ref.: Bibl. No. 19, vol. 1, pl. 139; No. 21, vol. 30, pls. 26, 27; No. 33, vol. 38, pls. 13, 15, 16; No. 58, pl. 434; No. 63, pl. 68

33 Tea bowl

Sung dynasty, 12th–13th century
Chien ware, hare's fur temmoku
H. 2⅞ in. (7.2 cm.); Diam. 5 in. (12.6 cm.)
Private collection

Although this *temmoku* tea bowl came to Japan in rather recent times and is not a true *densei* piece, the beauty of its shape and glaze has brought it renown as one of the finest examples of Chien ware with hare's fur (J. *nogi-me*) markings. The markings of typical hare's fur glaze *temmoku* are rather thin and feathery. On this bowl, however, the silvery blue streaks on the interior, which are roundish in form, are similar to the rounded spots of *yōhen* (iridescent) *temmoku*. The glossy black glaze is thickly applied, forming a ridge where the glaze gathered around the sides above the foot. The rather coarse dark gray clay used in Chien ware *temmoku* fires to a dark chocolate brown on the exposed unglazed area. The clay body is thick and porous.

In China *temmoku* tea bowls were used as ceremonial tea drinking vessels in temples of the Ch'an (Zen) sect and when Ch'an Buddhism was transmitted to Japan, they were introduced as one of the necessary tea ceremony utensils. Almost twenty kilns in Fukien and Chekiang provinces are known to have manufactured these black glazed tea bowls. A Japanese version of this ware was produced by the Seto and Mino potters during the fifteenth and sixteenth centuries.

Ref.: Bibl. No. 8, pl. 270; No. 19, vol. 1, pl. 141; No. 21, vol. 30, pls. 30, 31; No. 33, vol. 38, pls. 19, 20

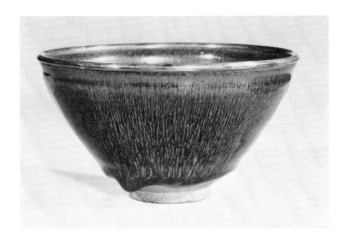 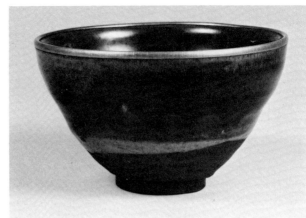

34 Tea bowl
Sung dynasty, 12th–13th century
Chien ware, hare's fur temmoku
H. 2⅝ in. (6.7 cm.); Diam. 5 in. (12.6 cm.)
Kyoto National Museum

In comparison to *yōhen* (iridescent glaze) and *yuteki* (oil spot) *temmoku* tea bowls, there are a number of *temmoku* tea bowls with hare's fur glaze in existence in Japan. Most have a matte black glaze with dark brownish spots, but few possess the beautiful feathery patterned glaze of this bowl. Japanese tea masters, among the most respected connoisseurs of Chinese ceramics, reveled in establishing elaborate classifications for Chinese *temmoku* tea bowls. In the Muromachi period, for example, *temmoku* ware was categorized according to type, and sub-categories were made depending on the size, color, and conformation of the spot-like glaze markings. Old records mention yellowish hare's fur and bluish hare's fur *temmoku* tea bowls, among other varieties. This bowl is distinguished by the pattern of finely mottled silvery spots over an unctuous black glaze and is considered perhaps the finest *temmoku* tea bowl of this type. It was no doubt produced at a Chien ware kiln during the Southern Sung dynasty. At one time it was in the possession of the influential Maeda clan of Kaga (modern Ishikawa Prefecture).

35 Tea bowl
Sung dynasty, 12th–13th century
Chien ware, haikatsugi temmoku
H. 2⅞ in. (7.1 cm.); Diam. 4¾ in. (12.0 cm.)
Private collection

Temmoku tea bowls with the distinctive grayish brown glaze seen on this bowl are called *haikatsugi* (ash-sprinkled glaze) *temmoku* in Japan. In comparison with the other varieties of *temmoku* tea bowls, *haikatsugi* bowls were not greatly appreciated in the fifteenth century. They were given a rather low classification in contemporary documents such as the catalogue which records Ashikaga Yoshimasa's Higashiyama collection. In the sixteenth century, however, when the aesthetic guidelines of the *wabi-cha* tea ceremony were established and a premium was placed on simple, natural materials in tea utensils, these tea bowls began to draw praise from tea masters. Thereafter their use is often cited in tea ceremony memoranda. Although the glaze is grayish and seems almost accidental, this was probably an effect deliberately achieved by the use of special glaze ingredients or firing conditions. This bowl was one of the famous *haikatsugi temmoku* bowls owned by the Tokugawa family in Kishu (modern Wakayama Prefecture) during the Edo period.

36 Tea bowl

Sung dynasty, 12th–13th century
Chi-chou ware, taihi temmoku
Diam. 4⅝ in. (11.6 cm.)
Private collection
National Treasure

The Japanese name for this type bowl, *taihi temmoku* (tortoise shell *temmoku*), derives from the markings on the exterior which recall the colors and mottling of natural tortoise shell. The name first appears in tea ceremony literature of the early Muromachi period. The *taihi temmoku* glazes were produced by special glazing techniques. First a black glaze was applied to the bowl, then paper patterns were laid on the interior in the form of the desired designs and the bowl was given an application of white glaze. This elaborate glazing method, combined with the natural changes in the glaze composition during firing, produced patches of different colors resembling tortoise shell markings on the exterior and a design pattern in reserve on the interior. It is thought that this was a glazing technique unique to the Chi-chou kilns in Kiangsi Province.

This superb example is one of the finest *densei taihi temmoku* tea bowls known in Japan. Although it was imported before the Momoyama period, its history is unknown prior to the middle of the eighteenth century when it was owned by a wealthy Osaka merchant named Ueda Saburōemon. He subsequently gave it to Matsudaira Fumai in 1778. Fumai, who loved and admired this bowl, classified it for the tea ceremony as an *ōmeibutsu*, or very high quality piece. Modern assessments support Fumai's opinion and the bowl has been designated a National Treasure.

Ref.: Bibl. No. 19, vol. 1, pl. 144; No. 21, vol. 30, pls. 34, 35; No. 29, pl. 20; No. 33, vol. 38, pls. 34, 35; No. 32, vol. 7, pl. 2; No. 58, pl. 435; No. 63, pl. 69

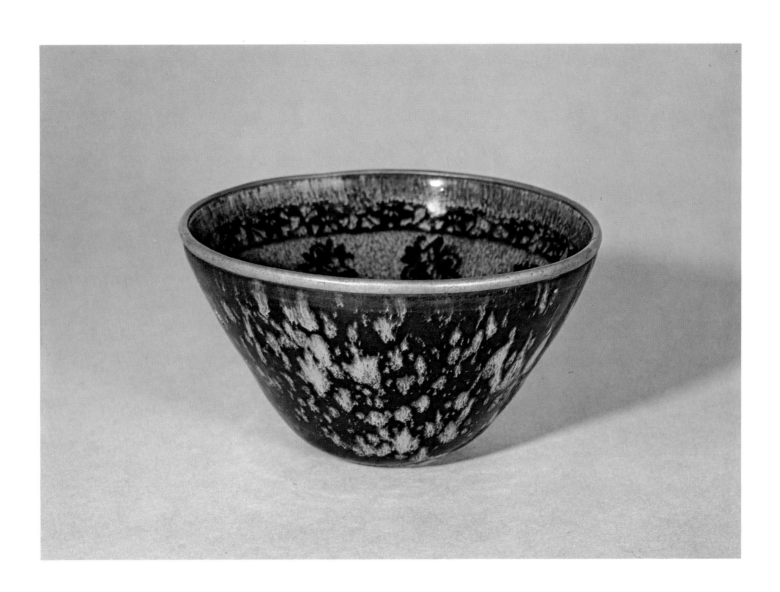

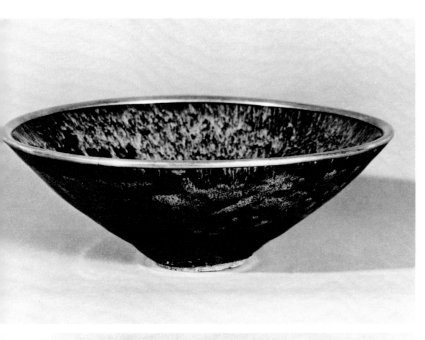

37 Tea bowl
Sung dynasty, 12th–13th century
Chi-chou ware, taihi temmoku
H. *2 in. (5.1 cm.); Diam. 6 in. (15.3 cm.)*
Kyoto National Museum

The term *taihi* (tortoise shell) *temmoku* encompasses a number of different designs, one of which is called *ran* (phoenix) *temmoku*. Even in this category, however, a few variations are recognized. The most typical *ran temmoku* is decorated with a pair of flying phoenixes in the center of the bowl, but this example is decorated with a single phoenix in flight and a floral spray. The delicate conception of the design and the somber glazes impart a soothing, quiet effect. With its small, carefully carved out foot, straight and only slightly rounded sides, and grayish white clay body, this bowl is typical of bowls produced at the Chi-chou kilns. The control of the glaze displays superb accomplishment and the piece has been preserved in perfect condition. A silver band has been affixed to the lip to mask the unglazed edge. This bowl was for a long time in the possession of the Maeda family, influential daimyo from Kaga Province (modern Ishikawa Prefecture). This type of *temmoku* bowl was frequently mentioned in records of the early Muromachi period, and it is believed that this piece was brought to Japan at that time.

Ref.: Bibl. No. 8, pl. 276; No. 19, vol. 1, pl. 147; No. 21, vol. 30, pls. 38, 39; No. 32, vol. 10, pl. 63

Interior

38 Tea caddy (*cha-ire*), named *Sōgo-nasu*
Sung–Ming dynasty, 13th–14th century
Brown-glazed ware
H. 3 *in.* (7.6 *cm.*)
Gotō Art Museum, Tokyo

Among tea ceremony utensils, the tea caddy (*cha-ire*) held a prominent position and fine quality examples were avidly sought and treasured by tea masters from the Muromachi to the end of the Edo period. Tea caddies of Chinese origin, known as *karamono cha-ire* in Japan, were considered especially desirable. Although the exact kilns which produced these tea caddies are not known, they were probably located in South China. Chinese tea caddies are characterized by their fine grained, dark brown clay containing iron impurities and their purplish brown glaze. The shapes are divided into eight basic types. Regarded as the finest example of the *nasu* (eggplant) type, this tea caddy is called *Sōgo-nasu* because it once belonged to Jūshiya Sōgo, a prominent merchant and famous tea master of the late Muromachi period. In the Momoyama period, the caddy was in the possession of Oda Sangorō, a brother of the military chieftain Oda Nobunaga, and in the Edo period, it was owned by the Tokugawa Government (*bakufu*). Tsuchiya Sagami-no-kami, a regent to the Tokugawa shogun, acquired it in 1694. Finally, in the 1950's, it was purchased by the Gotō Art Museum.

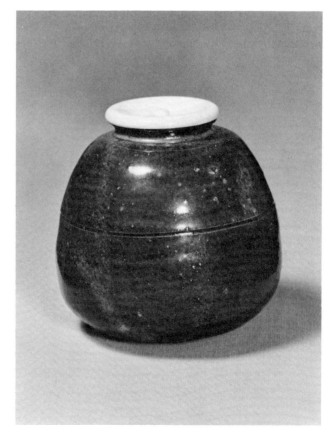

40 Jar with dragon design
Yüan dynasty, 14th century
Ching-tê-chên ware
H. 11⅝ *in.* (29.3 cm.)
Tokyo National Museum

The Ching-tê-chên kilns in the Jao region of Kiangsi Province were famous in the Sung dynasty for the production of *ch'ing-pai* ware, which was referred to as *Jao-yü* (Jao jade) in Chinese. In the succeeding Yüan dynasty these kilns began to manufacture blue and white porcelain for the first time in history. This ware has a fine white porcelain body with designs painted in cobalt blue under a transparent glaze. It was fired in a reducing atmosphere at a high temperature, resulting in a vitreous, sometimes translucent, white porcelain body with vibrant blue painting. As the popularity of blue and white porcelain increased rapidly during the Ming and Ch'ing dynasties, it became the major product of the Ching-tê-chên kilns. It was also one of the types of Chinese ceramics most coveted throughout the world, as is attested by examples found on the beaches of Kamakura in Japan, on the coast of Africa, and at Fostat (Old Cairo) in Egypt. More recently, pieces made during the early period in the history of blue and white production, in the fourteenth and early fifteenth centuries, have attracted considerable attention from scholars and collectors. This jar, with an underglaze blue design of a dragon chasing a jewel amidst swirling clouds, is not a *densei-hin* but is thought to have been exported from China to Southeast Asia during the Yüan period. It arrived in Japan in contemporary times. The rounded shoulder and wide mouth are characteristic of Yüan dynasty blue and white porcelain; moreover, both the design of the dragon chasing a jewel and the wave pattern around the neck are common fourteenth-century motifs. The composition is dramatic and well conceived and the bold, vigorous painting style is also typical of the period. The base was only slightly undercut and has been left unglazed.

Ref.: Bibl. No. 19, vol. 2, pl. 10; No. 62, vol. 1, pl. 31; No. 63, pl. 82; No. 66, vol. 41, pl. 31

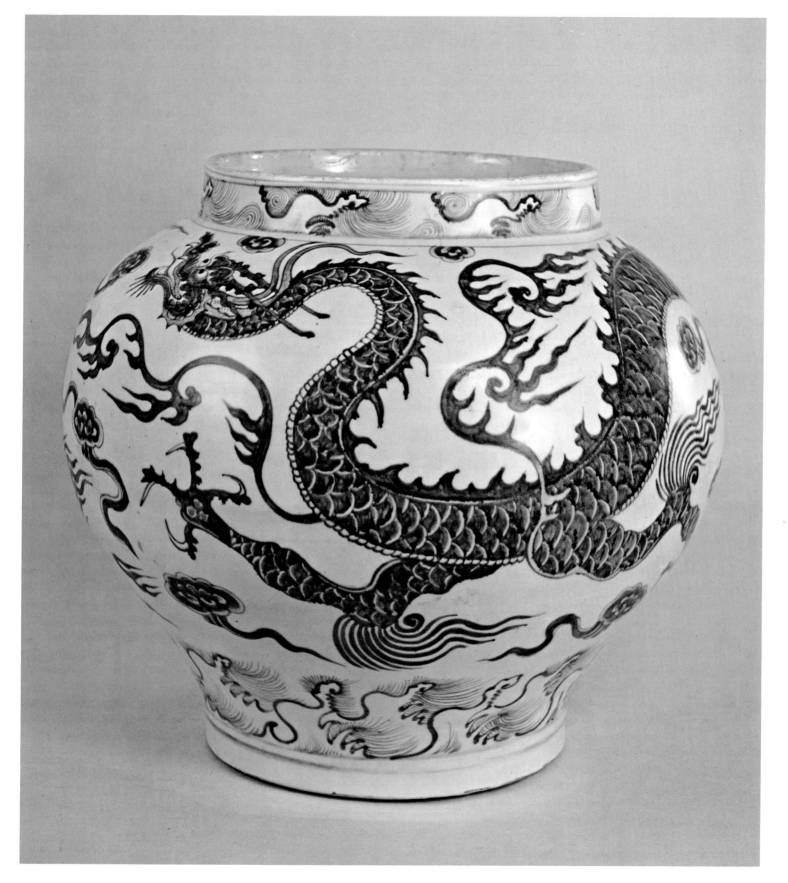

39 Tea caddy (*cha-ire*), named *Rikyū Enza*

Sung–Ming dynasty, 13th–14th century
Brown-glazed ware
H. 3⅜ *in. (8.5 cm.)*
Gotō Art Museum, Tokyo

The shape of this tea caddy, also a *karamono cha-ire*, is called *enza katatsuki* because it has a decisive shoulder line (*katatsuki*) and a thick, rounded foot which recalls the shape of the round straw cushion (*enza*) found in Zen temples. The sharply out-turned lip of this small vessel gives it a strong character. The purplish brown glaze which covers the upper portion has small white opaque glaze "tear drops" running over the surface; the lower part is unglazed. This caddy has an illustrious history. In the Muromachi period, it was in the collection of the Honnō-ji in Kyoto; then, in the Momoyama period, it came into the possession of Miyoshi Chōkei, a leading warrior and tea master. It also entered the collection of the noted military ruler, Toyotomi Hideyoshi (1536–1598), who subsequently bestowed it on Sen-no-Rikyū (1522–1591), his personal tea master and artistic advisor. Due to its association with Rikyū, who was probably the most influential and dynamic figure in the development of tea ceremony aesthetics in Japan, it is frequently referred to as *Rikyū Enza*. After Rikyū's death, the caddy came into the possession of the Tokugawa Government. During the 1960's it became part of the famous collection of tea ceremony wares at the Gotō Art Museum.

Ref.: Bibl. No. 63, pl. 141

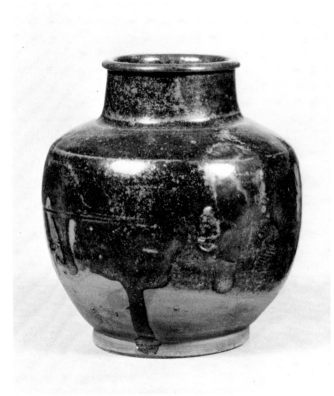

Base

41 Bottle

Ming dynasty, second half of the 15th century
Ching-tê-chên ware
H. 7 ¼ *in.* (18.4 *cm.*)
Private collection

Although recent scholarship and scientific excavations have
proven that Chinese blue and white porcelain was imported to
Japan as early as the fourteenth century, only a few *densei* blue and
white porcelains are dated to the fourteenth and fifteenth cen-
turies. This bottle, a *densei* piece without a clear history of owner-
ship, was produced at a non-imperial kiln of Ching-tê-chên in the
second half of the fifteenth century. The shape and design, how-
ever, retain the style of the blue and white wares of the Yüan
dynasty. The crisp profile of this bottle with its rather wide, out-
turned lip, narrow neck, and pear-shaped body is in the Yüan tra-
dition as is the compartmented design of picture medallions and
panels of stylized floral and vegetal motifs. The spacious distribu-
tion of the motifs on the body leaves larger areas undecorated,
however, than is characteristic of Yüan period bottles. This bottle
is one of the few fifteenth-century blue and white porcelains made
at non-imperial kilns that have survived. A similar bottle was exca-
vated in Yomitani village on the main island of Okinawa in 1974.

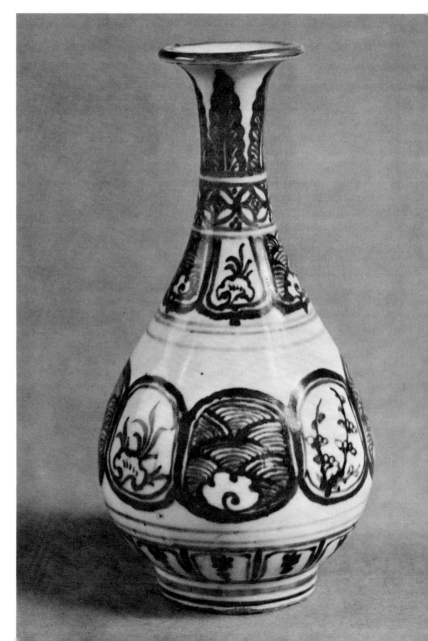

42 Group of fragments
Yüan–Ming dynasty, 14th–15th century
Celadon, blue and white, and enameled wares
Okinawa Prefectural Museum, Naha

These ceramic fragments were among the more than four thousand excavated from Katsuren Castle on Okinawa, the site of four separate excavations since 1965. Among these shards were several important types. Especially interesting were pieces of blue and white wares of the Yüan period and T'zŭ-chou ware with a brilliant copper oxide blue glaze over iron brown painted decoration. Both of these types of ware are rarely found on the main islands of Japan. The earliest piece among the vast array of excavated material probably dates from the Sung period, but many Yüan and Ming ceramic fragments were uncovered as well, including celadons and black glazed wares. Perhaps the most unusual finds were several fragments of polychrome Annamese ware. The diverse nature of these shards is proof of the wide range of trading contacts in Okinawan history.

B

C

43 Jar

Yüan dynasty, 14th century
Ching-tê-chên ware
H. 20⅛ *in.* (50.9 *cm.*)
Umezawa Memorial Museum, Tokyo
Important Cultural Property

Underglaze red porcelain was first produced at the Ching-tê-chên kilns in the fourteenth century, contemporary with the manufacture of Yüan dynasty blue and white. The underglaze red (Ch. *yu-li-hung*) was obtained from oxide of copper and, as was the case with the cobalt blue used for the blue and white wares, the mineral pigments were painted directly on the white biscuit body. A transparent white glaze was subsequently applied and the piece was then fired in a reducing atmosphere to achieve a glossy glaze over the copper red design. If the firing went well, the color became a fine crimson, but as the precise atmospheric conditions necessary for a perfect firing were difficult to maintain, the red color often darkened, turning to a muddy reddish brown or gray, or blurred over onto the white background areas. Because of the difficulty in firing the underglaze copper red, this technique was abandoned in the Ming dynasty in favor of an overglaze iron red enamel. This unusually large and spectacular jar was made in five parts and joined. Its shape, with an everted mouth and pronounced shoulder curve, was a form typical of fourteenth century underglaze red porcelain and similar jars are known to exist. The swelling body is subtly fluted with twelve vertical divisions; eight horizontal bands of varying widths containing flowers, stylized foliate motifs, and geometric patterns decorate the piece. A different floral motif, of flowers such as gardenias, lilies, chrysanthemums, lotuses, peonies, and camellias, is depicted in each of the twelve large vertical panels which dominate the central portion of the vase. While the underglaze red painting is rather dark and has blurred in many areas of the design, these imperfections only serve to create a bold impression. The transparent white glaze is glossy with small, partially ruptured surface bubbles in places. The base is unglazed and burnt slightly orange due to iron particles in the clay body. This large jar must have been produced at Ching-tê-chên sometime in the late Yüan or very early Ming period. It was already in Japan before the Second World War and was later acquired by Hikutarō Umezawa.

Ref.: Bibl. No. 8, pl. 303; No. 19, vol. 2, pl. 16; No. 29, pl. 21; No. 63, pl. 80; No. 66, vol. 41, pl. 21; No. 73, no. 28, pl. 3

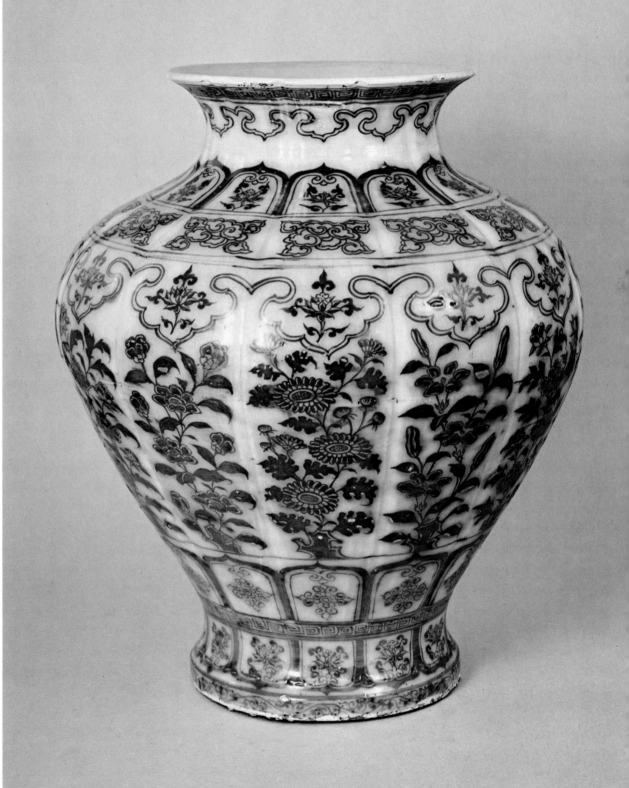

44 Vase, named *Yoshino-yama*
Ming dynasty, 14th–15th century
Lung-ch'üan celadon
H. 8⅜ *in.* (21.2 *cm.*)
Umezawa Memorial Museum, Tokyo

This vase, a Ming celadon in the shape of an ancient Chinese bronze *ku*, has been admired since the Edo period as one of the finest pieces of its kind. Because of its large size it was particularly suitable for use as a flower vase in the *tokonoma* (alcove) of a small tea room. It was once owned and revered by Kobori Enshū (1579–1647), an innovative tea master and trend setter in the early Edo period, and is listed in the catalogue of his possessions. Enshū named it *Yoshino-yama* (Mt. Yoshino). It later came into the collection of Matsudaira Fumai (1751–1818), daimyo of Izumo, who owned many tea ceremony utensils recognized as masterpieces (see also Nos. 32, 36). Recently the vase was acquired by the Umezawa Memorial Museum, Tokyo.

In Japan, Lung-ch'üan celadons with the olive green glaze seen on this piece are classified as the *Tenryū-ji* type, taking their name from a Kyoto temple that carried on trade with China during the Muromachi period and imported celadons.

86

45 Bowl with design of dragons

Ming dynasty, 15th century
Mark and period of Hung-chih (1488–1505)
Ching-tê-chên ware
H. 3⅛ in. (7.9 cm.); Diam. 7⅛ in. (18.0 cm.)
Umezawa Memorial Museum, Tokyo (right)

This bowl with slightly everted rim is believed to be a *densei* piece, although its hereditary owners are unknown. A slightly modified form of this type of bowl appears in Shu-fu ware produced for imperial use at the Ching-tê-chên kilns during the Yüan dynasty. However, the exact prototype for this shape, which became a favorite type of bowl in the Ming dynasty, is found among the imperial wares of the Hsüan-tê period (1426–1435). This particular piece bears the six-character mark of Hung-chih (1488–1505) in a double circle on the base. The exterior of the bowl is decorated with two dragons chasing pearls among clouds. The same theme is depicted on the interior of the vessel but the bodies of the dragons are arched to form a circle and the jewel is placed in the center. The theme and composition were common at the imperial kilns. The underglaze blue is brilliant and of superb quality.

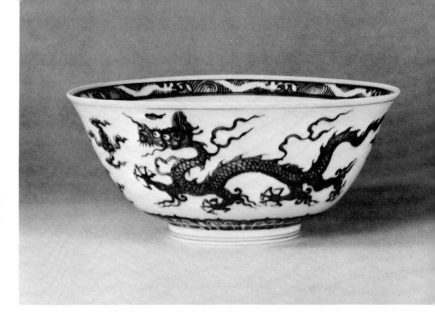

46 Tea bowl

Ming dynasty, 15th–16th century
Ching-tê-chên ware
H. 3¼ in. (8.1 cm.); Diam. 4⅜ in. (11.1 cm.)
Private collection (opposite)

Bowls such as this one, with an underglaze blue design of pavilions among swirling clouds, were especially admired by tea masters in the second half of the sixteenth century. This particular example was probably originally designed for use as an incense burner, but in Japan it was creatively adapted for use as a tea bowl in the formal tea ceremony. Sen-no-Rikyū (1522–1591), the leading tea master of the Momoyama period, owned a similar bowl. It is not known when this piece was imported to Japan, but from its style it is presumed to have been produced at a non-imperial kiln in Ching-tê-chên sometime during the reign of Chêng-tê (1506–1521) or Chia-ching (1522–1566), if not earlier. Since the Edo period, it has been in the possession of the Maeda family, the daimyo of Kaga (modern Ishikawa Prefecture).

Ref.: Bibl. No. 19, vol. 2, pl. 48; No. 13, vol. 42, pls. 72, 73; No. 43, pl. 301; No. 63, pl. 100

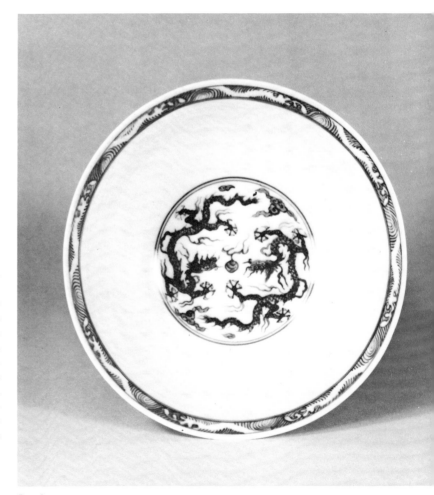

Interior

49 Jar with design of figures in a landscape
Ming dynasty, 16th century
Three-color ware, fa-hua type
H. 12⅛ *in.* (30.8 *cm.*); *Diam.* 7 *in.* (17.7 *cm.*)
Tokyo National Museum
Important Art Object

The depiction of figures in a landscape with pavilions is based on themes from early Ming literature and is a motif frequently encountered on ceramics. The body of the jar is made from a hard porcelaneous clay and decorated in polychrome glazes. Shades of blue predominate, primarily brilliant royal blue and turquoise blue. A limited amount of white and brown glaze is used for definition of the design. Carefully made and beautifully colored *fa-hua* ware like this jar was probably produced in Shansi or Honan Province in China. At one time, however, this type of *fa-hua* ware was mistakenly believed to be a variety of Cochin China (modern Vietnam) three-color ware. In fact, the three-color ware of Cochin China is a rather coarse, unrefined ware differing considerably from *fa-hua*. This jar was once in the possession of the Aoyama family, a famous warrior family that provided vassals to the shogun in the Edo period. Recently it was purchased by Tamesaburō Yamamoto, who donated it to the Tokyo National Museum.

Ref.: Bibl. No. 19, vol. 2, pl. 54; No. 21, vol. 30, pl. 102; No. 58, p. 448; No. 62, vol. 1, pl. 34

47 Bowl decorated with female figures

Ming dynasty, 16th century
Ching-tê-chên ware, ko aka-e type
H. 3¼ in. (8.2 cm.); Diam. 7 in. (17.6 cm.)
Private collection

Wares decorated in overglaze polychrome enamels on a white porcelain glaze are called *wu-ts'ai* (five colors) in China and *aka-e* (red decorated) or *nishiki-de* (brocade style) in Japan. The origins of this decorative technique can be traced back to the T'zŭ-chou kilns of the late twelfth or early thirteenth century. The technique was subsequently used at the Ching-tê-chên kilns in the Yüan dynasty and reached its ultimate development during the Ming dynasty. Although *aka-e* is a generic term in Japanese for polychrome enamel wares, different classifications which depended on the period of manufacture and style were established for Chinese wares of this type. During the Edo period when these wares were actively sought after by the Japanese, two categories were created for Ming and Ch'ing *aka-e*. Those of late Ming or early Ch'ing manufacture were termed Nanking *aka-e*, after the city of Nanking in southern China near the port from which they were exported to Japan. The prefix *ko* (old) was added to the ware designation *aka-e* for those Ming enameled wares which represented a distinct style created prior to the Wan-li period (1573–1619). Though *ko aka-e* was manufactured in the early Ming period, its production soared during the Chêng-tê period (1506–1521) and reached maximum heights during the reign of Chia-ching (1522–1566). This example is datable to the middle of the sixteenth century.

The exterior of the bowl is decorated with a design of ladies enjoying the pleasures of a garden, a design popular on non-imperial wares from the Yüan period onwards. The compositional device of separating the design into two scenes with a pictorial divider of billowing clouds and rounded earth mounds was also used on the tea bowl, No. 46. A design of ropes of jewels in enamel colors is depicted on the interior of the bowl. The exquisite painting and bright colors are typical of *wu-ts'ai* decorated ceramics of the Chia-ching period. Although its historical owners are unknown, this is believed to be a *densei* piece.

Ref.: Bibl. No. 58, pl. 451

48 Water jar (*mizusashi*)

Ming dynasty, 16th century
Three-color ware, fa-hua type
H. 3⅞ *in.* (*9.7 cm.*)
Private collection
Important Art Object

Fa-hua is a Chinese term which refers to a type of Ming three-color (*san-ts'ai*) ware that is distinguished by the application of threads of clay onto the body to outline the design and contain the polychrome enamel glazes. This cloisonné-like style of decorating ceramics is believed to have been a special technique used at kilns in Shansi Province in China during the fifteenth and sixteenth centuries. The white, purple, and dark blue glazes against a turquoise blue ground on this bowl are typical of the color combinations found on examples of this ware. Often dazzlingly opulent, these brightly colored ceramics became popular in Japan during the early Edo period and many *densei fa-hua* pieces are found in Japanese collections. Famous among these is a bowl, very similar to this one, in the collection of the Rokuon-ji in Kyoto. The size and shape of this bowl make it eminently suitable for use as a water jar (*mizusashi*) in the tea ceremony. The bowl has been preserved in virtually perfect condition.

Ref.: Bibl. No. 19, vol. 2, pl. 58; No. 43, pl. 376; No. 63, pl. 120

51 Octagonal double-gourd vase
Ming dynasty, 16th century
Ching-tê-chên ware, kinran-de type
H. 14¾ *in. (37.5 cm.)*
Private collection

Porcelains decorated with gilt designs on a colored enamel ground are called *kinran-de* (gilt brocade design) in Japan. *Kinran-de* ware, produced in large quantity during the Chêng-tê (1506–1521) and especially the Chia-ching (1522–1566) reigns, was not simply a category of *wu-ts'ai* (five-color) ware with gold decoration, but represented a series of completely new shapes and original decorative designs which set it apart from typical enameled *wu-ts'ai* types. In *kinran-de* porcelain, the gilt motifs were the dominant design while the polychrome enamel areas formed background decoration. The result was strikingly novel and gorgeous in effect. This octagonal double-gourd bottle is decorated in gold on a red enamel ground. Each panel of the faceted shape is decorated on the lower part with a design of flowers and birds and on the upper part with lotus scrolls. Bordering these pictorial areas are three horizontal bands, one containing the Eight Precious Treasures (near the base) and the other two the Chinese character for longevity, *shou* (near the waist and mouth). Generally in pieces as elaborately decorated as this one, the overall design appears cluttered and the painting is somewhat crude; however, this piece with its finely painted designs is exceptional. One seldom finds an example of old *kinran-de* ware where the gold is as well preserved as it is on this bottle. Usually the gold designs have chipped or show worn areas that detract from the beauty of the piece. Although the historical ownership is unknown, this is surely a *densei* piece and without question the finest *kinran-de* octagonal bottle in existence.

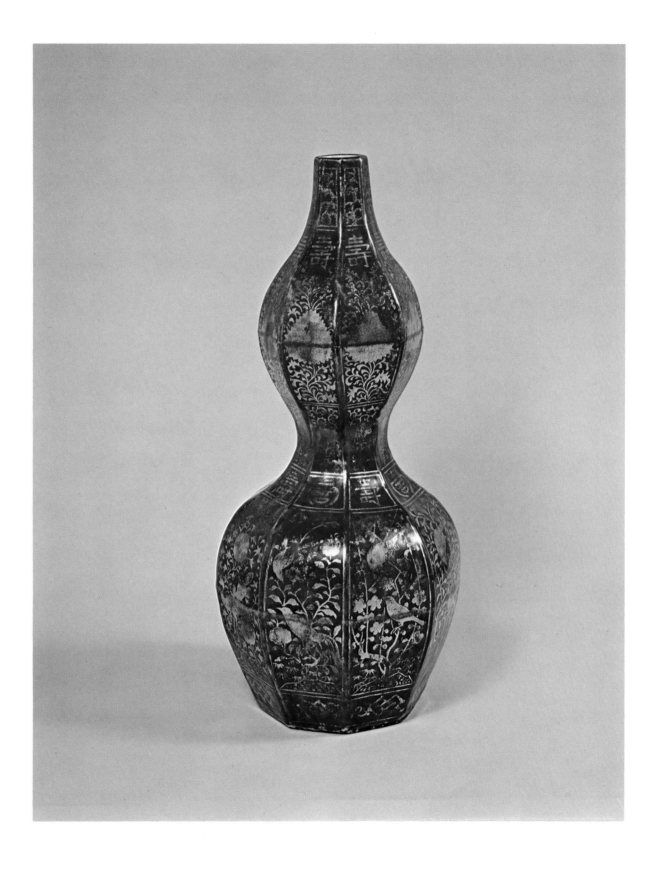

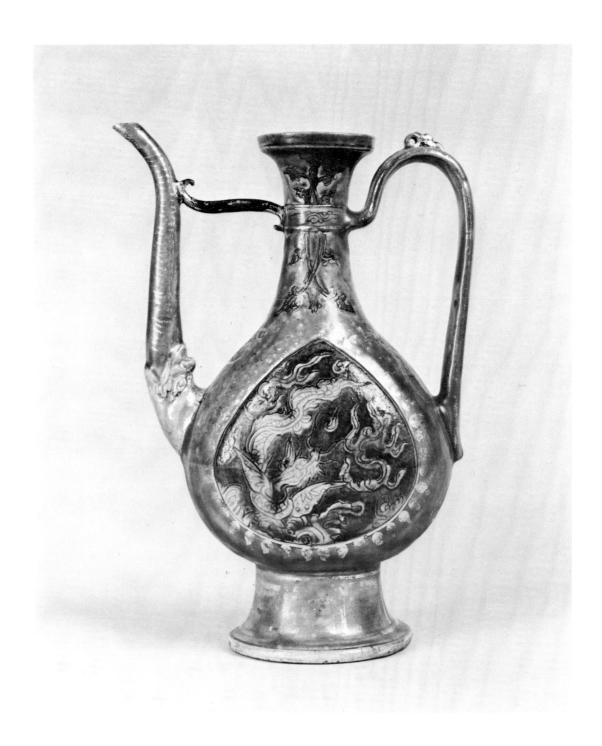

50 Ewer

Ming dynasty, 16*th century*
Three-color ware
H. 9¾ *in.* (24.6 *cm.*)
Egawa Museum of Art, Hyogo Prefecture (*opposite*)

This type of ewer is called *hsien-chan-ping* in China, and its stylistic origin can be traced to ewers of the Yüan dynasty. By the late Ming period, the shape had taken on delicate lines, giving it an elegant profile. A large quantity of ewers of this type was produced in the Chia-ching period (1522–1566), but this example may date from the Chêng-tê period (1506–1521), as it is stylistically similar to a ewer in a Portuguese collection that bears the coat of arms of Manuel I of Portugal (1465–1521). An example of Ming three-color ware, the ewer has a biscuit body decorated with blue, purple, and yellow glazes. The large, ovoid medallion on either side of the flask-shaped body was incised with a design of a winged dragon (Ch. *ying-lung*). Incised floral scrolls encircle the neck and patterns painted in gold adorn the otherwise plain areas of the ewer. An animal head in relief is visible at the base of the spout. The color scheme which is dominated by dark, warm shades gives the ewer a tranquil feeling. The overall effect of the decorative scheme is close to *fa-hua* ware (see Nos. 48, 49). This is believed to be a *densei* piece, though the history of its ownership is not known.

Ref.: Bibl. No. 63, pl. 1

52 Water dropper and brush stand

Ming dynasty, 16*th century*
Ching-tê-chên ware, kinran-de type
H. 4⅝ *in.* (11.6 *cm.*); *Diam.* 4⅝ *in.* (11.7 *cm.*)
Tokyo National Museum; gift of Mr. Matsushige Hirota

This compactly designed writing accessory has a cylindrical water dropper at the center, surrounded by three circular containers that are thought to be receptacles for washing or storing brushes and an oblong container that probably held an ink stick. While red is the dominant enamel color used for the background pattern of horizontal bands and lozenge-shaped medallions that encircle the piece, green and blue enamels were used to color various motifs and to provide highlights. The floral scrolls which decorate the solid red panels and bands were painted in gold. Each motif was carefully rendered in an effort to create a sumptuous object for the scholar's desk. Although gold originally adorned the knob of the water dropper, much of it has worn off, indicating that this object was used frequently. On one of the small circular containers is an inscription: *kuei-yu-hsien-yüan-yang* (the cyclical year *kuei-yu*, Yang at Hsien-yüan). It is said that this writing accessory box was owned by a man named Yang who passed the examination for governmental officers at Hsien-yüan in the year of *kuei-yu*. During the sixteenth century, when this piece was presumably made, the cyclical year of *kuei-yu* fell in 1513 and 1573, suggesting that this writing box was produced in either one of these two years.

Ref.: Bibl. No. 32, vol. 11, pl. 101; No. 62, vol. 1, pl. 37

53 Ewer with openwork design

Ming dynasty, 16th century
Ching-tê-chên ware, kinran-de type
H. 11⅛ *in. (28.2 cm.)*
Gotō Art Museum, Tokyo
Important Cultural Property

This ewer is regarded as one of the best examples of *kinran-de* ware in Japan. It is the same shape as No. 50. The neck of this ewer is more attenuated, however, and has a shapely, soft curve which provides an elegant lift to the profile. Peacocks painted in gold stand among peonies in the pierced openwork design that decorates the jewel-shaped medallion on each side of the ewer. While the medallion decoration is in the characteristic *kinran-de* style, the remainder of the ewer is decorated in the *wu-ts'ai* style, with the addition of gold. Through constant use, much of the gold has been worn away. This ewer was manufactured during the Chia-ching period (1522–1566) and was probably imported to Japan in the Edo period. Its early history in Japan is unknown.

Ref.: Bibl. No. 12, vol. 43, pl. 65; No. 19, vol. 2, pl. 71; No. 21, vol. 30, pl. 100; No. 29, pl. 93; No. 32, vol. 11, pl. 99; No. 43, pl. 342; No. 58, pl. 452; No. 63, pl. 110

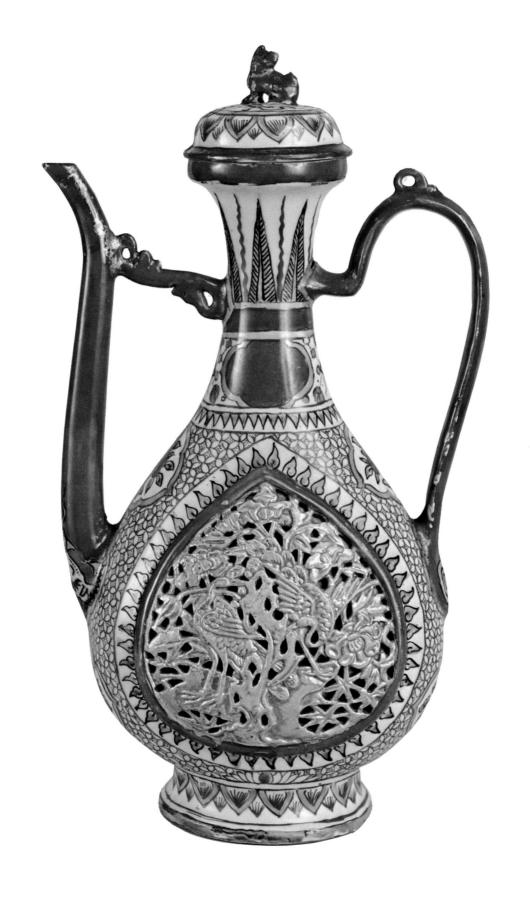

54 Ewer in the shape of a kettle

Ming dynasty, 16th century
Ching-tê-chên ware, kinran-de type
H. 9 *in.* (22.7 *cm.*)
Gotō Art Museum, Tokyo

Ewers in the shape of a kettle are rarely found in *kinran-de* decorated porcelain. The prototype of this ewer can be traced back to metalwork of the Five Dynasties period, but few examples exist even from the succeeding Sung, Yüan, and Ming dynasties. The principal design on this ewer depicts the Eight Sages of China: Chung-li, Chang-kuo-lao, Han Hsiang-tz'u, T'ieh Kuai-li, Ts'ao Kuo-chiu, Lü Tung-pin, Lan Ts'ai-ho, and Ho Hsien-ku. These stately figures are portrayed with descriptive, flourishing brushwork and vividly colored enamels in the *wu-ts'ai* style. The upper part of the body and the spout are decorated in the *kinran-de* manner with a limited use of gold painted designs over the red and blue enamels. This ewer, the vase (No. 19), the group of *kinran-de* bowls (No. 55), the brush tray (No. 59), and the cup (No. 76) were once in the possession of the Kōnoike family, wealthy merchants in Osaka.

Ref.: Bibl. No. 19, vol. 2, pl. 75; No. 58, pl. 453

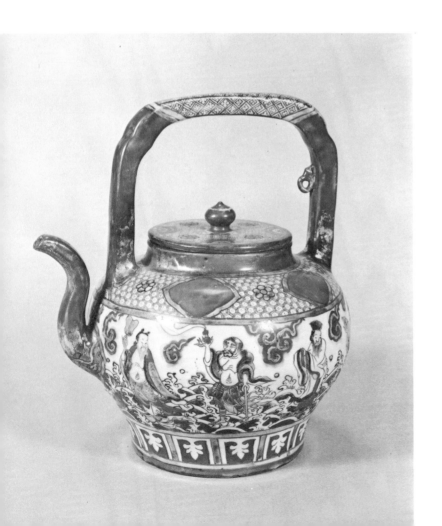

55 Set of five bowls

Ming dynasty, 16th century
Ching-tê-chên ware, kinran-de type
Diam. 5⅛ in. (12.8 cm.)
Private collection
Important Cultural Property

The *kinran-de* bowls in this group are in superb condition. The gold decoration, which has worn off so many other examples of *kinran-de* ware, is beautifully preserved. On the interior of each bowl are simple underglaze blue designs of chrysanthemum sprays in the center and a diaper border around the rim. In contrast, the exterior of each is opulently decorated with medallions and geometric motifs in polychrome enamels and gold. Above the foot is a lotus petal border executed in red and green enamels. The gold design is in the form of gold leaf, applied over a bright red enamel ground. This decorative scheme, together with the use of stylized floral motifs on a geometrically patterned ground, is typical of *kinran-de* style decoration. A four-character Chinese inscription of good omens, *wan-fu-fang-t'ung*, appears in underglaze blue on the base of each bowl. These bowls were used to serve food in the *kaiseki* meal service which formed part of the tea ceremony and were at one time among the treasures of the Kōnoike family in Osaka.

Ref.: Bibl. No. 19, vol. 2, pl. 78; No. 58, pl. 454; No. 63, pl. 109

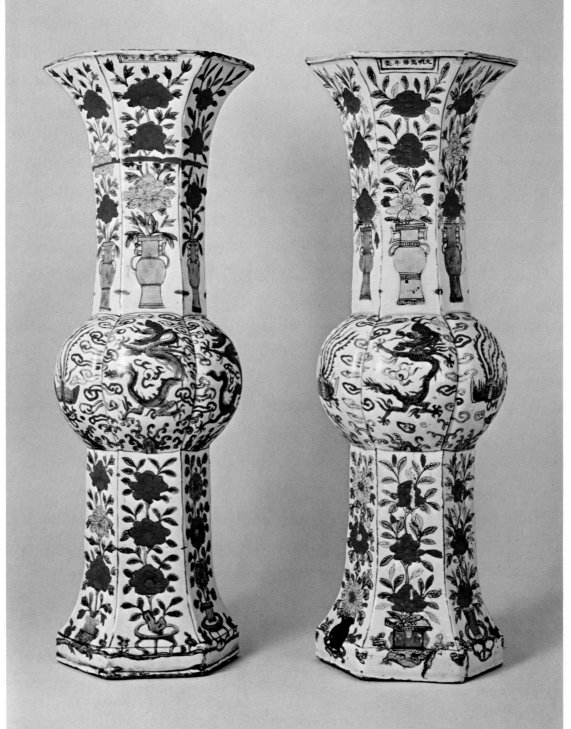

56 Pair of vases in the shape of *tsun*
Ming dynasty, 16th–17th century
Ching-tê-chên ware, wu-ts'ai type
Mark and reign of Wan-li (1573–1619)
H. 23½ in. (59.3 cm.)
Honnō-ji, Kyoto

The shape of this pair of hexagonal vases is a Ming dynasty version of the ancient Chinese bronze *tsun*. Designs of potted floral arrangements are arranged around the flaring neck and lower portion of each vessel. Dragons and phoenixes, typical of the Wan-li style of underglaze blue and overglaze enamel decoration, are depicted around the bulbous midsection. The bold, free brushwork and the dense floral decoration are characteristic of imperial wares of the Wan-li period (1573–1619) and each vase bears a six-character Wan-li mark in underglaze blue just below the lip. They were probably produced late in the reign. For centuries these vases have been kept at the Honnō-ji in Kyoto. According to the inscription on an old storage box for one of the vases, the pair was presented to the temple by Chaya Nakajima Chōemon in 1645. Although it is commonly believed that these vases were imported to Japan in the early Edo period, nothing is known of their history before the date of the presentation to the temple.

Ref.: Bibl. No. 12, vol. 43, pl. 24; No. 21, vol. 30, pl. 106; No. 43, pl. 353; No. 63, pl. 116

57 Basin with design of sages
Ming dynasty, 16th–17th century
Ching-tê-chên ware, wu-ts'ai type
Mark and period of Wan-li (1573–1619)
H. 3⅜ in. (8.4 cm.); Diam. 13¾ in. (34.8 cm.)
Eisei Bunko Foundation, Tokyo

Large quantities of colorful enameled porcelain, produced at the imperial kilns during the Wan-li period, were brought to Japan beginning in the early Edo period. Pieces of superb quality became family heirlooms and, consequently, many fine examples are preserved in Japanese collections to this day. Among the innovations in enameled ware introduced at the Wan-li imperial potteries were a variety of new shapes. One of these is illustrated by this large basin with five foliated sides and a wide, everted rim. The interior bears a scene of figures in a landscape, probably a depiction of "LaoTzu Giving a Farewell Discourse" (*Lao-tzŭ-ch'u-kuan*), taken from the sutra called *Lao-tzŭ-hua-hu-ching*. LaoTzu was an important early Chinese philosopher instrumental in formulating the body of religious and social thought known as Taoism. One of the traditional stories based on Taoist dogma is represented here; however, the depiction is used less as a vehicle for the expression of Taoist thought than as pure design. The scene does not narrate so much as project the vibrant combinations of the enamels to create a rich and colorful impression. It was precisely this use of strikingly vivid overglaze enamels in the Wan-li reign which received high praise from Japanese collectors and admirers during the Edo period. On the base is a six-character mark of Wan-li in underglaze blue.

Ref.: Bibl. No. 43, pl. 357; No. 58, pl. 460

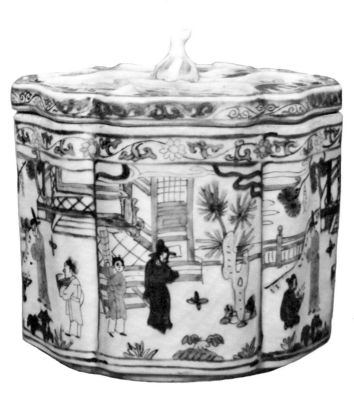

58 Water jar and cover (*mizusashi*)
Ming dynasty, 16th–17th century
Ching-tê-chên ware, wu-ts'ai type
Mark and period of Wan-li (1573–1619)
H. 5 1/8 *in.* (13.0 *cm.*); *Diam.* 5 1/2 *in.* (14.0 *cm.*)
Hatakeyama Memorial Museum, Tokyo

Although it is difficult to state with certainty for what use this covered container and others like it were originally intended, it is probable that they were accessory boxes for a Chinese scholar's writing desk. In Japan, however, such pieces were adapted for use as water jars (*mizusashi*) in the tea ceremony. Several almost identical containers of this type have been preserved in Japanese collections. The thickly formed porcelain body of this jar is typical of the Wan-li period, although the enamel colors are somewhat less vivid than the usual Wan-li colors. Both the convoluted shape, complete with conforming cover, and the narrative design, executed in underglaze blue and enamel overglaze colors, are among the outstanding achievements in ceramics of this period. The dominant design encircling the lobed sides of this box depicts several stately figures, who seem to be officials, in a terraced garden. Whether this design narrates a specific story is uncertain and probably was of no concern to the decorator. On the cover, six petal forms with raised outlines encircle a handle that imitates the calyx and stem of a flower. A six-character Wan-li mark is inscribed in underglaze blue on the base. In the late nineteenth and early twentieth centuries, this covered box was owned by the Fujita family of Osaka, whose collection included a number of famous tea utensils. Prior owners are unrecorded.

64 Water jar and cover (*mizusashi*)

Ming dynasty, 17th century
Ching-tê-chên ware, ko sometsuke type
H. 10⅛ *in.* (25.6 *cm.*); *Diam.* 6¼ *in.* (15.7 *cm.*)
Private collection

In the early Edo period, tea masters sought a more decorative type
of *mizusashi* than had been used before and many *ko sometsuke* style
mizusashi were ordered from China. This water jar, modeled after
a traditional Japanese wooden pail, was presumably made to or-
der for Japanese tea masters. The thick-bodied ware with its soft
surface tone clearly recalls the original wooden prototype. Verti-
cal underglaze blue lines suggest that broad slats of wood form the
sides. Within the rectilinear framework created by these lines are
designs of cranes and clouds (top row) and fish and waterplants
(bottom row), painted in a style typical of Chia-ching and Wan-li
porcelain. The floral scrolls on the handle relate to similar motifs
on late Ming wares. The Chinese style designs imbue this rather
sober, workaday shaped vessel with a stately, graceful air. The
cover knob, in the shape of a cut bamboo stem, was a motif par-
ticularly favored by tea masters.

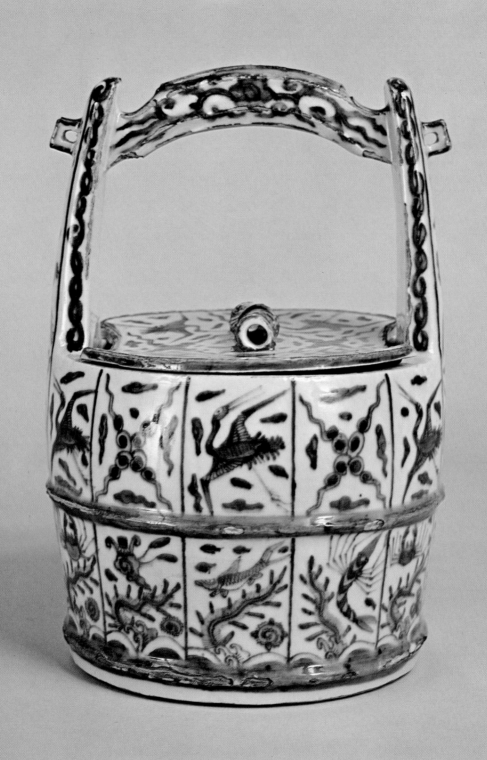

59 Rectangular brush tray

Ming dynasty, 16th–17th century
Ching-tê-chên ware, wu-ts'ai type
Mark and period of Wan-li (1573–1619)
L. 9¾ in. (24.8 cm.); w. 4¼ in. (10.8 cm.)
Tokyo National Museum; gift of Mr. Matsushige Hirota

Many writing accessories, such as brush holders, water droppers, and ink slabs, were made in the imperial kilns during the late Ming dynasty, but rectangular brush trays like this one were only rarely produced. Dividing the interior of the piece is a brush support in the shape of mountain peaks. The brushes rested in the concave depressions. The pottery body is thickly formed and the foot is low and squat. The entire tray is ornamented with dragons in underglaze blue and overglaze enamels. In addition, the heads of the pair of dragons on the interior are modeled in relief, providing them with especial vitality. The bold colors and vigorous design typify the Wan-li style and this rectangular brush tray is surely among the finest five-color pieces of this period. On the base, within a double rectangle, is a six-character Wan-li mark in underglaze blue. During the Edo period, this tray was in the possession of the Kōnoike family in Osaka.

Ref.: Bibl. No. 62, vol. 1, pl. 41

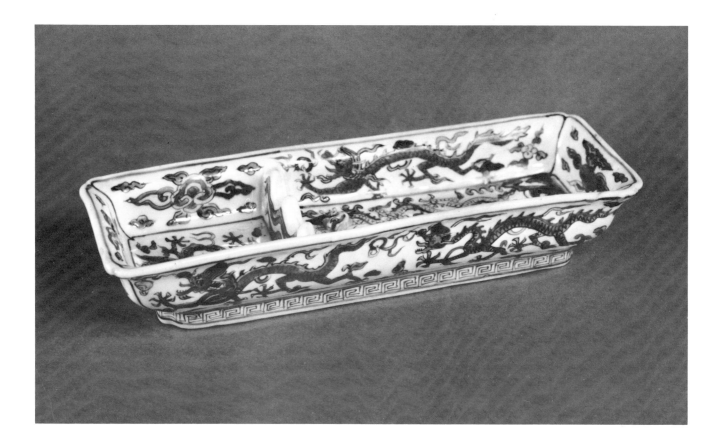

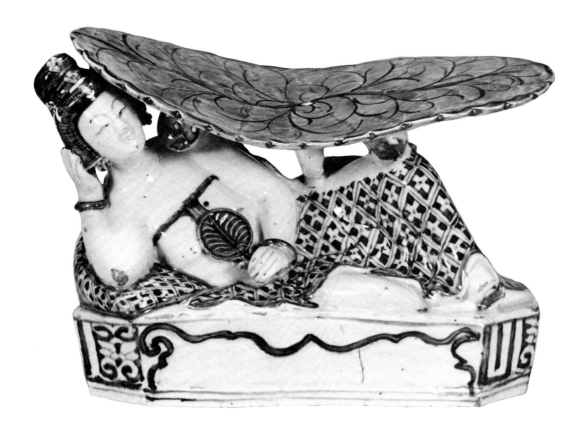

60 Pillow
Ming dynasty, 16*th century*
Ching-tê-chên ware
H. 6⅝ *in.* (17.0 *cm.*); *Diam.* 9¾ *in.* (24.7 *cm.*)
Private collection

During the Chia-ching period (1522–1566), the non-imperial kilns at Ching-tê-chên produced many items of specialized use such as incense burners, ewers, and pillows in the shape of female figures. Examples of this aspect of porcelain production exist in blue and white ware, *wu-ts'ai* enameled ware, and *kinran-de* ware. This pillow was ingeniously devised, utilizing a female figure reclining on a bed to support a large spreading lotus leaf which forms the head rest. Ceramic pillows with lotus leaf head rests are commonly found among Chinese ceramics. An exceptionally fine example is the Ting ware pillow in the Asian Art Museum of San Francisco, The Avery Brundage Collection. Examples in Tz'ŭ-chou ware can also be cited, but this design is infrequently found in Ching-tê-chên porcelain of the Ming dynasty, which makes this piece exceptional. Although there is no reign mark on the piece, the full proportions, hair style, and physiognomy of the figure are all consistent with the figure style of the Chia-ching era. The stylized floral patterns on the angled corners of the stand also appear on well-established Chia-ching ceramics. The dark blue color and the faulting in the glaze at the edges of the piece are characteristics of the products of non-imperial kilns in the late Ming period. Over the centuries Japanese tea masters, connoisseurs, and antiquaries have developed an extensive descriptive vocabulary for ceramics, and glaze faults such as these, in which small amounts of glaze flake off the edges to reveal the body, have been termed *mushikui*, or "insect nibbles." This pillow is known to have been in the possession of the Maeda family in Kaga Province (modern Ishikawa Prefecture).

Ref.: Bibl. No. 13, vol. 42, pl. 92; No. 43, pl. 313

61 Vase in the shape of a *tsun*

Ming dynasty, 17th century
Ching-tê-chên ware, ko sometsuke type
H. 12½ *in.* (31.4 *cm.*)
Idemitsu Art Gallery, Tokyo

This vase belongs to a category of underglaze blue porcelains labeled *ko sometsuke* (old blue and white) in Japan, a designation used for blue and white wares produced at non-imperial kilns at Ching-tê-chên during the T'ien-ch'i period (1621–1627). The term was probably coined in the early twentieth century. In the Edo period, this kind of blue and white ware had simply been called *sometsuke* (blue and white ware) or Nanking *sometsuke* (blue and white ware from Nanking).

There are two groups of *ko sometsuke* ware found in Japan. The first is comprised of thinly made bowls and dishes which were mass produced and imported to Japan in great numbers. The second group consists of tea ceremony utensils such as water jars (*mizu-sashi*), small bowls, and vases made to the order of Japanese tea masters. These wares are generally thick bodied and the decorative motifs and shapes are often purely Japanese. As they were made specifically for Japanese customers, few examples of this type are found anywhere but in Japan. The shape of this vase is called *naka kabura* (turnip-shaped middle) in Japanese because of the bulbous midsection. The shape seems to have been a new design, although the two handles in the apparent shape of atrophied elephant heads are traditional elements derived from earlier Chinese bronze and ceramic forms. The Chinese character for longevity, *shou*, painted in underglaze blue on either side of the body, forms the central decorative motif. This sparse decoration preserves an understated elegance approved by Japanese tea votaries. A similar vase is in the collection of the Hakutsuru Art Museum, Hyogo Prefecture.

Ref.: Bibl. No. 27, no. 134; No. 32, vol. 7, pl. 110

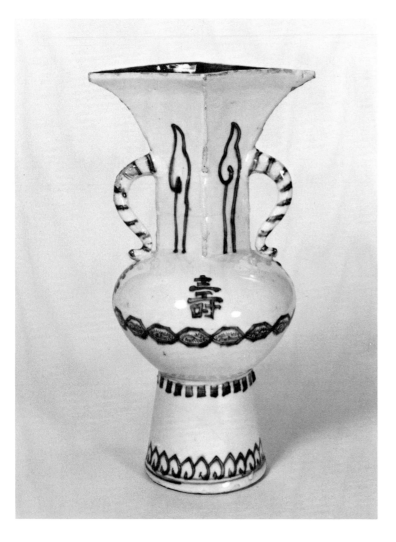

62 Vase with fish handles
Ming dynasty, 17th century
Cheng-tê-chên ware, ko sometsuke type
H. 9¾ *in. (24.6 cm.)*
Private collection

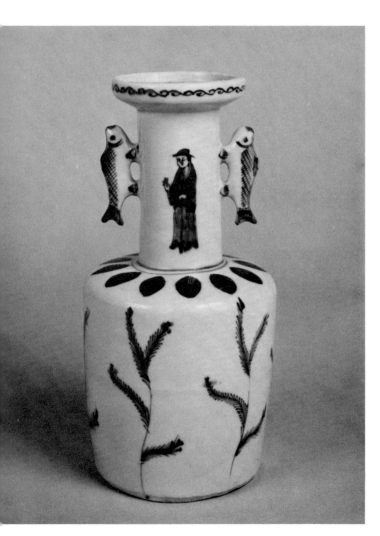

In its formative phases, the development of tea ceremony etiquette and philosophy in Japan was dependent on other traditional arts, particularly the Nō drama, which provided antecedents for the stylized movements, formal dress, and spiritual mood that became essential components of the fully developed tea ceremony. Thus, historically, tea masters had a close understanding of Nō. Depicted in underglaze blue on either side of the neck of this vase are an old man and woman, Chinese symbols of longevity. Because they resemble characters in the Nō play, *Takasago*, Japanese tea masters in the Edo period referred to ceramics with this symbolism as *Takasago* style.

A characteristic example of *ko sometsuke* ware, this vase is in the mallet (*kinuta*) shape, with each handle modeled in the form of a carp. The prototype for this shape can be found among Lung-ch'üan *kinuta* celadons of the Sung dynasty. In fact, it is thought that vases such as this one were made to order for Japanese tea masters who desired contemporary versions of the earlier Lung-ch'üan celadon type of vase. Several vases in this shape, all similarly decorated with floral petals around the shoulder and algae-like plants on the body, are in Japanese collections. This fine example of *ko sometsuke* ware is a type of vase which was highly favored by tea masters as a container for flowers which decorated the *tokonoma* (alcove) during the formal tea ceremony. The hereditary owners are unknown, but it is undoubtedly a *densei* piece.

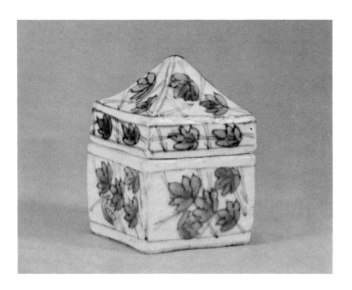

63 Incense box

Ming dynasty, 17th century
Ching-tê-chên ware, ko sometsuke type
H. 2⅝ *in.* (6.6 *cm.*); L. 1⅞ *in.* (4.7 *cm.*)
Gotō Art Museum, Tokyo

Incense boxes (J. *kōgō*) are used in the tea ceremony either as decorative items placed in the *tokonoma* (alcove) for the admiration of the guests, or as receptacles for the incense that was burned with charcoal in the brazier. Although such boxes are among the smallest utensils used in the tea room, they have always been accorded great importance and, through the centuries, have been singled out for special esteem by tea masters. During the Ansei era (1854–1859), a list of famous incense boxes, which simulated the status lists used in *sumō* wrestling matches, was compiled. As if for a match, two equally ranked pieces were chosen in each of several categories. Usually, incense boxes of Chinese origin were given higher rank, and this piece was given the first position, together with a celebrated enameled Cochin ware incense box in the form of a turtle. This box has a cover in the shape of a pyramidal roof and the entire form suggests a small Japanese shrine called a *tsujidō*, the name by which this type of incense box is known in Japan. The body is decorated with a design of autumn maple leaves painted in a soft underglaze blue, which harmonizes with the tranquil atmosphere of a tea room. A few other *densei* incense boxes in this *tsujidō* shape are known but this one is perhaps the finest.

65 Water jar and cover (*mizusashi*)

Ming dynasty, 17th century
Ching-tê-chên ware, ko sometsuke type
H. 7⅞ *in.* (19.8 *cm.*)
Private collection (opposite)

Among *ko sometsuke mizusashi* is a type called *katamono mizusashi*, or "water jars which conform to a standard model." Some *katamono* pieces were made from a mold, hence their shape was standardized. Others are similar to each other in shape and decoration but are not molded wares. Among the *katamono mizusashi* which belong in the latter group are water jars decorated with a design of fruit bearing vines, those with a design of cherry blossoms and streams, and those that imitate the shape of a wooden pail (see No. 64). These varieties of *katamono* water jars are thought to have been specially ordered by Japanese tea masters from the Ching-tê-chên kilns. It seems likely that masters transmitted their ideas for shapes and pictorial designs either in sketches or in the form of actual examples of native Japanese pottery, such as Oribe ware, for the Chinese to copy. This octagonal water jar is decorated with fruiting vines and trellises in vivid underglaze blue. A similar jar with a fruiting vine design, though of round rather than octagonal shape, bears a T'ien-ch'i reign mark (1621–1627), and it seems likely that the present piece was also made about that time.

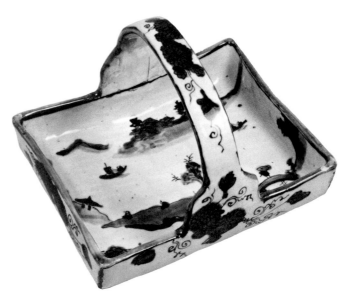

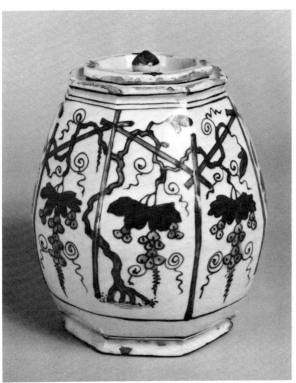

66 Rectangular dish with bail handle

Ming dynasty, 17th century
Ching-tê-chên ware, ko sometsuke type
H. 5⅜ *in. (13.6 cm.)*; L. 8⅝ *in. (21.8 cm.)*;
W. 6¾ *in. (17.2 cm.)*
Private collection (above)

Dishes with handles, called *tebachi* in Japanese, were often pro-
duced at the Mino and Bizen kilns in Japan during the Momo-
yama period. In the early Edo period, Japanese tea masters sent
orders to reproduce this native Japanese ceramic shape to the
Ching-tê-chên kilns in China along with their requests for other
tea ceremony utensils such as *mizusashi*, bowls, and incense boxes.
There are various types of *tebachi* in the *ko sometsuke* style, but only
a few rectangular dishes with handles are still extant in Japan.
The body of this piece was thickly molded and is slightly misshapen.
The handle is similar in style to those on Oribe ware dishes which
had been made in Japan since the Momoyama period. The under-
glaze blue painted design of a landscape with figures suggests a
poetic mood, characteristic of many *ko sometsuke* designs. Painted
chrysanthemums and scrolls appear on the exterior of the handle
and the deep sides. The base is unglazed.

67 Hexagonal dish with loop handles

Ming dynasty, 17th century
Ching-tê-chên ware, ko sometsuke type
Diam. 9½ in. (24.0 cm.)
Tokyo National Museum; gift of Mr. Matsushige Hirota

It is not clear whether this shape, a hexagonal dish with a wide flat rim, originated in China or Japan. However, the underglaze blue design on the interior showing a Japanese imperial coach with courtiers was a common design during the Momoyama and Edo periods. Moreover, the two small handles are modeled in the shape of an obi, the Japanese sash tied around a kimono. Clearly the piece was made for the Japanese market. Thickly formed and painted with rather rough brushwork, the dish has an understated charm characteristic of many *ko sometsuke* designs. The heavy hexagonal foot rim was roughly carved out. The dish was used to serve food in the *kaiseki* meal service associated with the tea ceremony.

Ref.: Bibl. No. 62, vol. 1, pl. 135

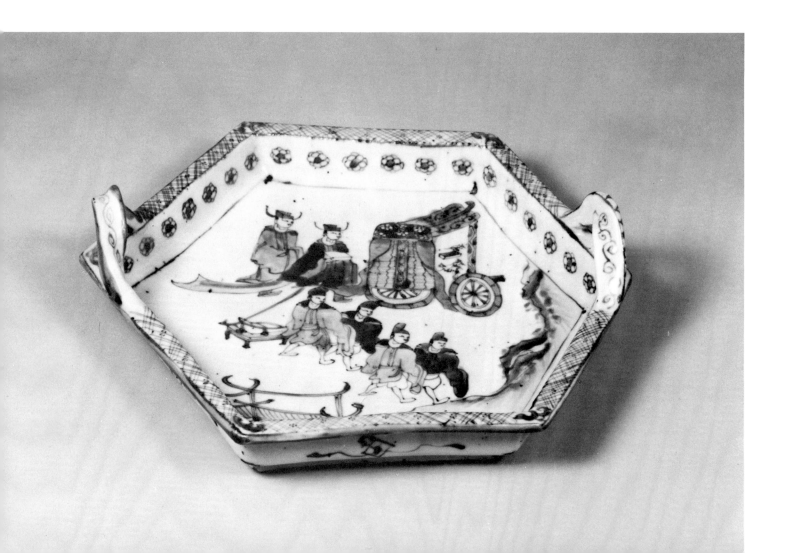

68 Vase

Ming dynasty, 17th century
Ching-tê-chên ware, ko sometsuke type
H. 6⅝ *in. (16.8 cm.)*
Tokyo National Museum; gift of Mr. Matsushige Hirota

One of the delights of *ko sometsuke* ware is the variety of shapes in which these ceramics were designed. Each piece has its own unique charm and intriguing personality. Small pieces of the *ko sometsuke* type such as this bottle were unusual among the products of the Ching-tê-chên kilns, which specialized in a variety of large-scale blue and white wares made for domestic use. Although many of the *ko sometsuke* pieces found in Japan were made to order for Japanese consumption and illustrate native Japanese aesthetics and taste, the shape of this vessel was not of Japanese origin. It belongs instead to a traditional Chinese vase type called *yüeh-ping-hu* (moon cake vase) after a type of pastry, filled with different delicacies, that is made for the Chinese harvest moon festival. The design of a fish ensnared in a net is commonly found on wares of the Wan-li period (1573–1619). For these reasons, this piece may not have been specially made for Japanese order. Nevertheless, its curious shape and striking design undoubtedly highly recommended it to Japanese tea masters for use as a flower vase in the tea ceremony. Although the names of its owners over the centuries are unknown, the vase is believed to have had a long history in Japan.

Ref.: Bibl. No. 62, vol. 1, pl. 132

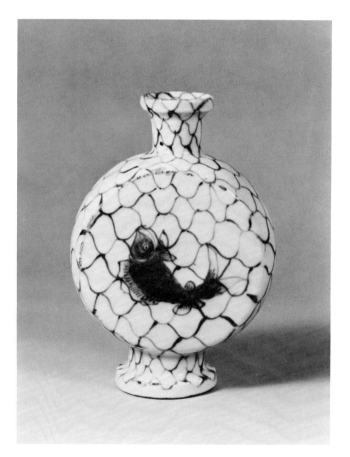

69 Five dishes (from a set of six)

Ming dynasty, 17th century
Ching-tê-chên ware, Tenkei aka-e type
Diam. 6⅞ in. (17.3 cm.)
Private collection

In Japan, this type of ware is referred to as *Tenkei aka-e*, a term only recently applied to enameled ware made during the T'ien-ch'i reign (1621–1627) in the late Ming dynasty. Since *ko sometsuke* was also being produced at Ching-tê-chên at this time and influenced its production, *Tenkei aka-e* ware can be viewed as a variation of *ko sometsuke* porcelain, with the addition of enamel colors. These dishes are used as a set for the formal *kaiseki* meal service which accompanies the tea ceremony. The Chinese divining blocks which form the dominant decorative designs are painted in underglaze blue and have a thick bright red outline which endows each small dish with a vigorous quality. Touches of yellow and green enamel appear on the circle pattern at the intersection of the cross formed by the divining blocks. Foliate scrolls painted in red enamels, interspersed with various motifs painted in underglaze blue, adorn the flat rim of each dish. Around the edge of the rim, there are many areas, called *mushikui*, or "insect nibbles" in Japanese, where the glaze has chipped due to technical imperfections in the manufacture. The style of these pieces is rather coarse, yet roughly made pieces like these were praised by Japanese tea masters and valued as tea utensils. These dishes were probably made at Ching-tê-chên during the late Ming dynasty. Their crooked, uneven shapes resting on three stubby feet suggest that they were produced especially for Japanese tea masters.

Ref.: Bibl. No. 12, vol. 43, pl. 26

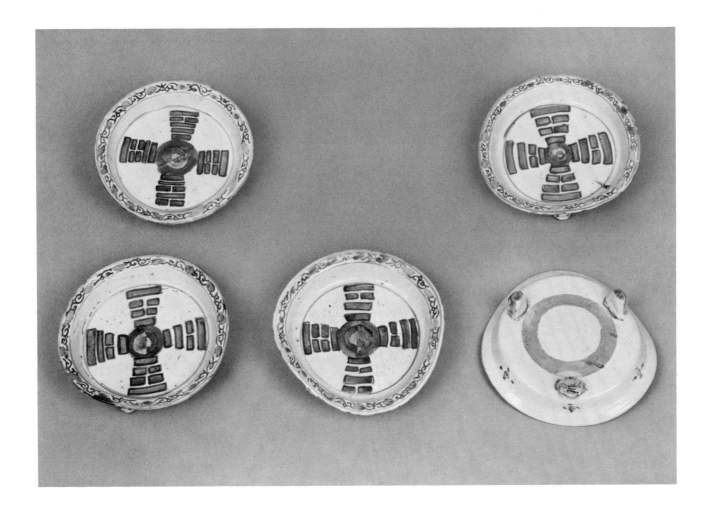

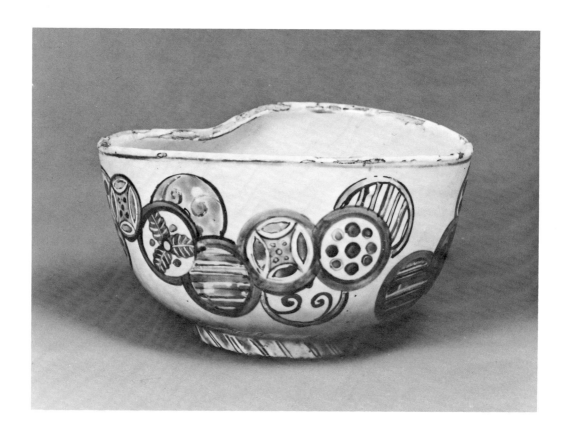

70 Bowl

Ming dynasty, 17th century
Ching-tê-chên ware, Tenkei aka-e type
Diam. 9 in. (22.8 cm.)
Private collection

This bowl is also an example of *Tenkei aka-e* ware, although the overall conception of this piece with its thickly formed body, marvelously distorted profile, and viscous white glaze is more typical of the *ko sometsuke* style. The distorted mouth rim is unusual for a Chinese-made porcelain and suggests that the bowl was made to Japanese order. The circular medallions, filled with various geometric and plant motifs, are painted in underglaze blue and overglaze green, red, and yellow enamels in the *Shonzui* style (see No. 71). Their sparse, free arrangement on the bowl is unconventional for Ching-tê-chên ware, although the medallion motifs themselves are commonly found on other products of this ceramic center. This may well mean that the design was requested by a Japanese patron who desired a porcelain decoration in the bold, asymmetrical style of Japanese textile design. The bowl would normally be used in the *kaiseki* meal service of the tea ceremony to contain pickles or sweets.

Ref.: Bibl. No. 52, vol. 45, pl. 17

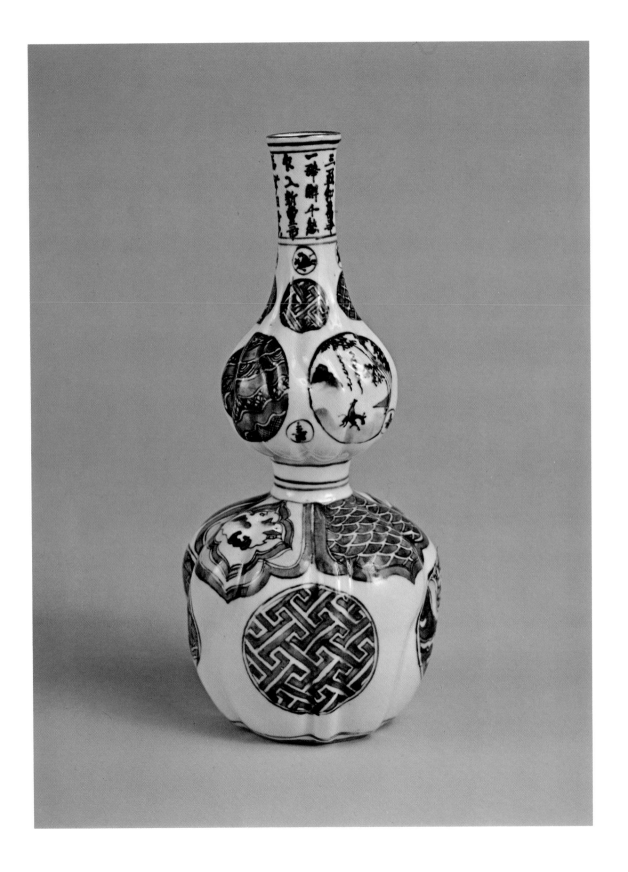

72 Double-gourd bottle

Ming dynasty, 17th century
Ching-tê-chên ware, Shonzui type
H. 7⅞ *in.* (19.9 *cm.*)
Tokyo National Museum; gift of Mr. Matsushige Hirota

This bottle is one of the most exquisite examples of *Shonzui* ware in the gourd shape. Although it does not bear the usual inscription found on *Shonzui* pieces, its grayish white clay body, containing fine-grained iron particles, together with its resplendent royal blue cobalt painting and glossy white glaze clearly designate it as *Shonzui* ware. The circular medallions and lappets on the shoulder, which enclose landscape scenes or complex geometric patterns, and the Chinese poem decorating the upper part of the neck are all artistically arranged, resulting in a striking and impressive design. The past owners of this bottle are not known, but it is believed to have been a *densei* piece.

Ref.: Bibl. No. 62, vol. 1, pl. 44

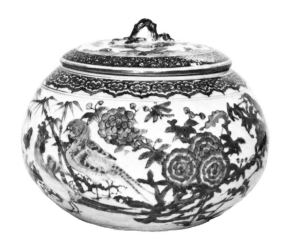

71 Water jar and cover (*mizusashi*)
Ming dynasty, 17th century
Ching-tê-chên ware, Shonzui type
H. 6⅞ in. (17.4 cm.)
Idemitsu Art Gallery, Tokyo

Since the Edo period, tea masters have highly valued the brilliant blue and white ware of the *Shonzui* type for tea utensils. The name *Shonzui* derives from a cryptic Chinese inscription, *Wu liang t'ai fu wu hsiang jui*, often found on examples of this ware. Once it was believed that *Shonzui* ware was produced by a Japanese potter called Gorōdaiyū Shonzui (the Japanese reading of the Chinese characters in the inscription) who, according to legend, went to China to learn porcelain making and produced so-called *Shonzui* ware after he returned. Lacking documentation, this theory is today regarded as suspect. However, *Shonzui* ware was made in a variety of shapes not seen before in Chinese ceramics, and it is believed that the ware was ordered in China by Japanese tea masters for tea ceremony utensils.

This water jar (*mizusashi*) has been made in the shape of a man-darin orange and decorated with a deftly painted scene of flowers and birds in a landscape setting. The complex geometric patterns which form a subsidiary design are a characteristic feature of *Shonzui* ware. As there is a small *Shonzui* ware container used for the storage of the tea cloth during the tea ceremony (*chakin-zutsu*) which bears the date 1635, it can be assumed that the ware was definitely produced during the reign of Ch'ung-chêng (r. 1628–1644), the last emperor of the Ming dynasty. This water jar, traditionally said to have been in the possession of the Hongan-ji in Kyoto, is one of the finest and most famous examples of *Shonzui* ware known.

Ref.: Bibl. No. 3, pl. 45, cat. no. 184

73 Dish with a foliate rim

Ming dynasty, 17th century
Ching-tê-chên ware, Shonzui type
Diam. 11¼ in. (28.4 cm.)
Tokyo National Museum; gift of Mr. Matsushige Hirota

This blue and white dish is often grouped with *Shonzui* ware, but it might better be classified as an example of Nanking *sometsuke* (Nanking blue and white ware) bearing a *Shonzui* style design. The term Nanking *sometsuke* refers to blue and white Ching-tê-chên porcelain exported to Japan from ports near the city of Nanking. On the basis of the earliest literary references, this term and the term Nanking *aka-e* (Nanking enameled ware) seem first to have been employed during the middle of the Edo period. Although the shape of this dish with deep sides and flat, foliated rim is characteristic of Nanking *sometsuke*, the design on the rim of four floral scroll medallions separated by panels bearing different geometric patterns is typical of *Shonzui* ware. The landscape design painted around the interior sides and the designs of lotuses, birds, and floral scrolls on the interior base are also clearly related to *Shonzui* decorative motifs. The representation of the eight Buddhist treasures on the exterior of the vessel is, however, reminiscent of the decorative style of Wan-li period porcelain. The dish thus embodies stylistic influences from several sources, making it difficult to classify it strictly according to type. Nonetheless its careful, accomplished painting and its luxuriant decorative style place it in the mainstream of late Ming Ching-tê-chên porcelain production.

Ref.: Bibl. No. 62, vol. 1, pl. 144

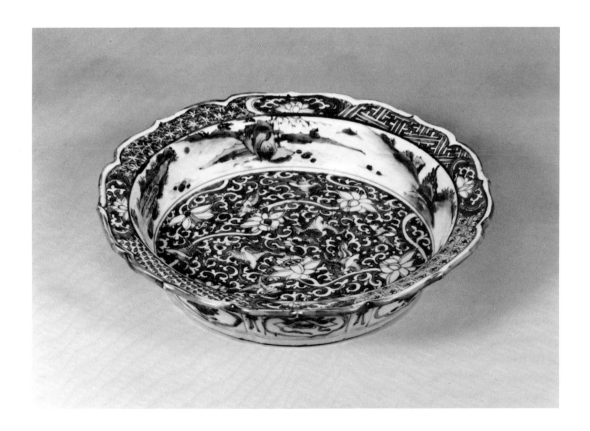

74 Tea bowl

Ming dynasty, 17th century
Ching-tê-chên ware, Shonzui type
H. 3¼ in. (8.3 cm.)
Gotō Art Museum, Tokyo

The unusual shape of this *Shonzui* style bowl with its constricted waist gave rise to the Japanese name *dojime* (waistband) for this form. Vessels with "waisted" shapes are often found among tea utensils such as small braziers (*hi-ire*), tea caddies (*cha-ire*), small dishes for the *kaiseki* meal (*mukōzuke*), and water jars (*mizusashi*), but this shape is rarely used for a tea bowl. No doubt this piece was designed originally for some other purpose and was only later adapted for use in drinking tea. The bowl is painted in a fine violet blue. On the lower part is a scene of a cock and hen in a mountain landscape, while the upper part is decorated with a band of assorted geometric motifs below which are roundels enclosing flowers, birds, and small landscape scenes in the typical *Shonzui* style. The inside of the bowl is completely glazed in blue. The Chinese character *fu* (good fortune) appears in underglaze blue on the base.

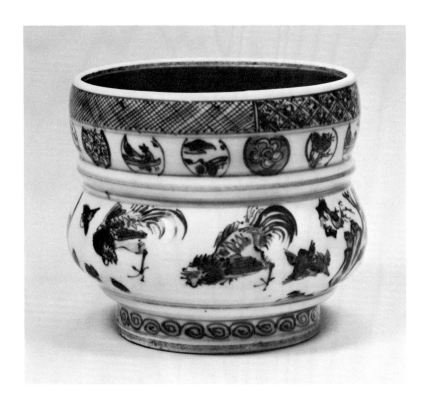

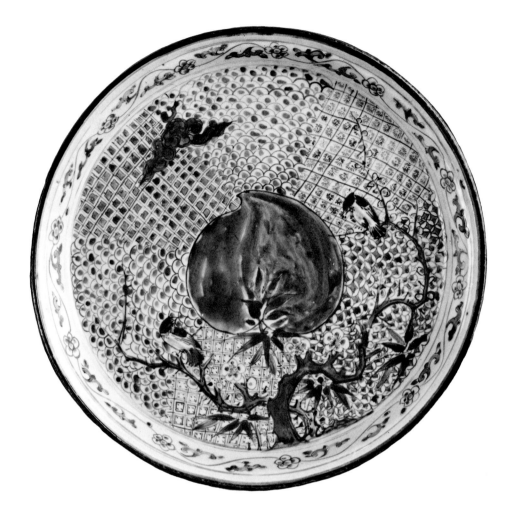

75 Dish

Ming dynasty, 17th century
Ching-tê-chên ware, Shonzui type
Diam. 10⅝ in. (27.0 cm.)
Tokyo National Museum; gift of Mr. Matsushige Hirota

Polychrome enameled ware with *Shonzui* style designs is termed *iro-e Shonzui* in Japan. This type of ware was produced at the Ching-tê-chên kilns in the late Ming dynasty, but few pieces have survived the vicissitudes of history. Thus, this dish is important as a fine, well-preserved example of the type. It has a flat, out-turned rim and flat center; the interior is decorated with a large peach circumscribed by several different kinds of geometric patterns. From below and to one side, partially framing the central peach, rises a small but vigorous prunus tree. Counterpoised on its two spreading branches are a pair of birds, and above appears a stylized cloud. While, at first glance, the many geometric patterns

forming the background seem to clash, they attain a certain coloristic harmony through the soft rhythms of the light cobalt blue and pale enamel hues. Peony sprays and bamboo leaves enliven the exterior of the bowl. On the base are the six-character mark of the Emperor Chia-ching (1522–1566) and the character *fu* (good fortune). Marks of earlier Ming dynasty reigns noted for the production of high quality ceramics were sometimes added to particularly fine pieces. The rim of the dish is decorated with a border of iron brown glaze.

Ref.: Bibl. No. 62, vol. 1, pl. 45

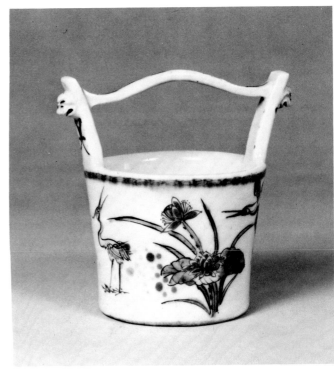

76 Cup in the shape of a wooden pail
Ming dynasty, 17th century
Ching-tê-chên ware, Nanking aka-e type
Diam. 3½ in. (8.8 cm.)
Tokyo National Museum; gift of Mr. Matsushige Hirota

This small Nanking *aka-e* porcelain container reproduces the shape of a Japanese wooden pail. It was used as an additional tea caddy during the tea ceremony to accommodate a reserve supply of powdered tea. Nanking *aka-e* was produced at non-imperial kilns in Ching-tê-chên during the late Ming and early Ch'ing dynasties. The name Nanking *aka-e* was coined during the Edo period for this type of ware because it was imported to Japan in large quantities from the Nanking district in southern China. The shapes, designs, and enamel colors of Nanking *aka-e* differ markedly from *ko aka-e* (see No. 77) and *Tenkei aka-e* (see Nos. 69 and 70) enameled wares. The painted designs are more closely akin to those of Ching-tê-chên porcelain produced for use in China. In comparison with Nanking *aka-e* enameled wares which were exported to Europe, the Middle East, and Southeast Asia, the pieces imported to Japan are rather small in size and their shapes often imitate Japanese forms associated with other media, as illustrated by this piece. This clearly suggests that their production was influenced by Japanese taste. The decisive brushstrokes delineating the design of lotus flowers and herons on this piece are characteristic of Nanking *aka-e* and imbue the cup with a refreshing vitality. Thought to have been produced at a Ching-tê-chên kiln in the seventeenth century, this porcelain pail was formerly in the possession of the Kōnoike family in Osaka and was part of a set of five identical pieces.

77 Bowl

Ming dynasty, 17th century
Swatow ware
Diam. 8⅛ in. (20.6 cm.)
Gotō Art Museum, Tokyo

In the West, enameled porcelain ware of this type is called Swatow ware after the Chinese port city of Swatow, in Fukien Province, from which it was exported. In Japan, it is known as *gosu aka-e* (red painted ware from the Wu district), *go* being the Japanese pronunciation of the Chinese region Wu where this ware was produced. Swatow ware was manufactured at provincial kilns in South China and, as it was made for the export trade, potters did not attempt to duplicate the matchless perfection of the masterpieces of the imperial potteries. The appeal of these wares lies in their unbridled freedom of conception and their naturalness. The painting is often rather awkward and rough, the glaze unrefined. Due to haphazard firing conditions, grit and sand are often present on the foot and base. Swatow type ware was exported to Southeast Asia, as well as the Near East, where fragments were excavated at Fostat (Old Cairo) in Egypt. Contemporary records verify that a great number of Swatow wares were brought to Japan in the first half of the seventeenth century. One important find of Swatow fragments was uncovered at the site of the Ichijō-in, a priests' residence hall at the famous Kōfuku-ji in Nara. These fragments must predate 1642 when the Ichijō-in was destroyed by fire.

This bowl is decorated in two styles: the birds and flowers are painted in the *ko aka-e* technique, but the background of geometric motifs with red and gold painted medallions is in the *kinran-de* style. Painted in underglaze blue in the center of the interior of the bowl is a design of a *kara-shishi*, the Japanese name for a fanciful creature which is half-lion, half-dog, shown here chasing a jewel. The *kara-shishi* design was particularly esteemed by tea masters for ceramics used in the tea ceremony. This type of bowl, distinguished by its colorful decoration and appropriate size, was considered most suitable by tea masters for serving sweets or boiled vegetables in the formal food service which accompanies the tea ceremony. One of the finest Swatow bowls in Japan, this is no doubt a *densei* piece, though the history of its ownership is not known.

Ref.: Bibl. No. 43, pl. 386; No. 52, vol. 45, pls. 40, 41; No. 63, pl. 146

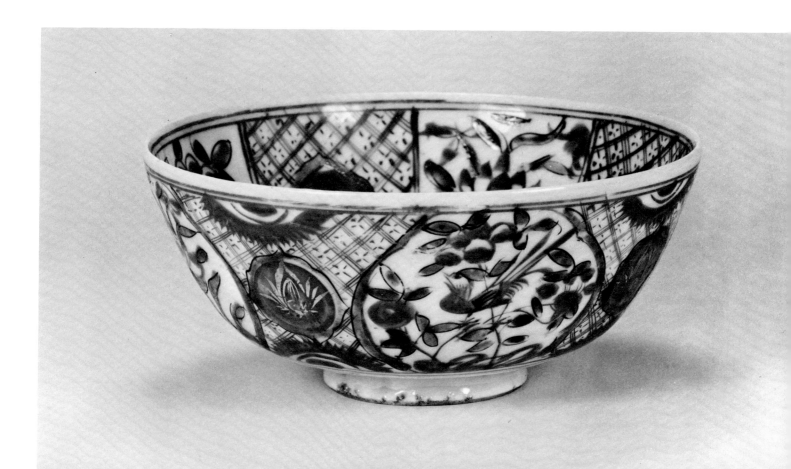

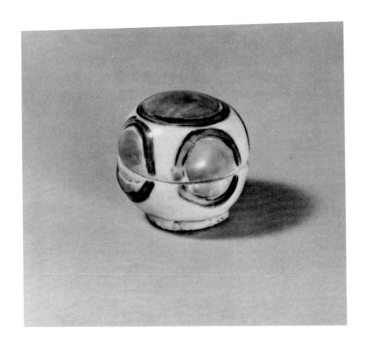

78 Incense box
Ming dynasty, 17th century
Swatow ware
H. 1¼ in. (3.0 cm.); Diam. 1 in. (2.5 cm.)
Tokyo National Museum; gift of Mr. Matsushige Hirota

Swatow ware (J. *gosu aka-e*) produced in South China was imported to Japan and the Philippines along with ceramic wares from Cochin China (modern Vietnam) during the sixteenth and seventeenth centuries. Although the most characteristic examples of Swatow porcelain were boldly and colorfully decorated large dishes and jars, small pieces were also made and these were given special recognition in Japan by the tea masters. The function which this small box served in China is not clear, but in Japan it was adapted for use as an incense box in the tea ceremony. Both large and small sized Swatow ware incense boxes are known and tea devotees assigned them subtle grades of quality and desirability. For example, in the grading of round incense boxes, those smaller in size like this tiny piece were considered more desirable than larger ones. Although the decoration of red and green circles is not very commonly found on Swatow ware, it was a design particularly relished by the Japanese and decorative motifs modeled on this prototype were copied on Japanese porcelain.

Ref.: Bibl. No. 52, vol. 45, pl. 42

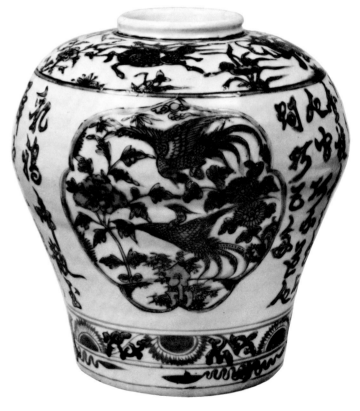

80 Bowl

Ming dynasty, 17th century
Swatow ware
Diam. 15⅞ in. (40.2 cm.)
Hatakeyama Memorial Museum, Tokyo
(following page)

Although the term Swatow ware is most commonly associated with the enameled wares (see Nos. 77–79) and the blue and white wares which formed the bulk of these export ceramics, the kilns which produced this so-called Swatow ware also produced blue glazed ware, white glazed ware, and iron brown glazed ware. These types were frequently decorated in underglaze designs formed by myriads of small dots of white slip. Among the most popular designs were those of flowers and dragons. Such pieces decorated with white slip are called *mochibana-de* (*mochi* flower style) in Japan, because the little white dots used to form the designs remind the Japanese of the small balls of rice cake (*mochi*) used to ornament willow branches at New Year's time. This large dish, a superb example of blue glazed Swatow ware, is in the *mochibana* style. The dragon design in the center is formed not only in white slip, but also in underglaze blue and iron brown, as is the border pattern of swastikas, repeated on the rim. The floral pattern on the cavetto is also in the *mochibana* style. The majority of pieces in this style are decorated very sparsely and simply, and few can equal this example for complexity of design and use of variegated colors. Fragments of related pieces have been excavated at the Ichijō-in site of the Kōfuku-ji in Nara, a building which was destroyed in 1642. This lends further support to the belief that this type of ware dates from the late Ming dynasty.

Ref.: Bibl. No. 52, vol. 45, pl. 15

79 Jar

Ming dynasty, 17th century
Swatow ware
H. 12 *in. (30.5 cm.)*
Private collection (opposite)

Among the Swatow wares are pieces decorated in a transparent marine blue enamel with touches of vermilion and green enamels. This type of Swatow ware, of which this jar is an example, is called *ao gosu* (blue *gosu*) ware in Japan. The designs of *ao gosu* ware were usually carefully and precisely rendered. The detailed outlines of the design were first painted in black and then filled in with blue enamel. Although a number of dishes with this style of decoration are known, most notably those bearing Chinese character seals in vermilion in the design, jars of the *ao gosu* type are very rare. The two large foliated panels on either side of this jar embrace a design of a pair of phoenixes with peonies and chrysanthemums. A Chinese poem was painted between the panels. Vertically arranged five or six to a column, the characters were outlined in black and filled in with blue enamel in the typical *ao gosu* style. Chinese mythological animals known as *ch'i-lin* cavort amidst flowers around the shoulder. The horizontal bands on the lower part of this vase contain boldly painted motifs in red and green enamels typical of *gosu aka-e* ware.

Ref.: Bibl. No. 43, pl. 384; No. 52, vol. 45, pl. 48

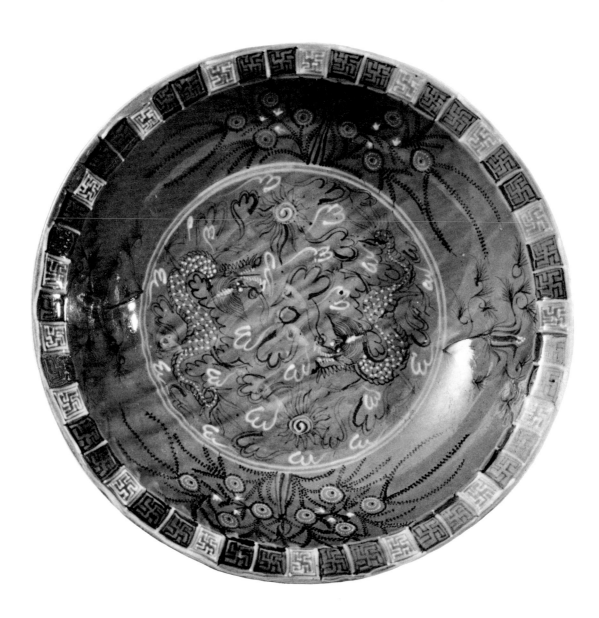

Noted Historical Collections
Represented in the Exhibition

Numbers refer to catalogue numbers.

Glossary

Aka-e:
J. "Red decorated ware"; i.e. overglaze enamel decorated ware. *See wu-ts'ai.*

Aka-e Shonzui:
J. "Red decorated *Shonzui* ware." Porcelain decorated in overglaze enamels with designs similar to *Shonzui* blue and white. *See Shonzui-de.*

An-hua:
Ch. "Secret decoration" or "hidden decoration." Decoration lightly incised or applied in very light slip on porcelain and visible only by transmitted light. The designs are usually floral scrolls, dragons and clouds, or lotus scrolls with the Eight Emblems of Buddhism.

Ashikaga Yoshimasa:
See Yoshimasa.

Ashikaga Yoshimitsu:
See Yoshimitsu.

Biscuit:
Fired but unglazed pottery.

Celadon:
High-fired wares with feldspathic glazes which take on a distinctive olive to blue green color from a small amount of iron oxide in the glaze when fired in a reducing atmosphere. A term applied particularly to Yüeh, Northern Celadon, and Lung-ch'üan wares.

Cha-ire:
J. Tea caddy.

Chajin:
J. Tea master.

Cha-no-yu:
J. Tea ceremony using powdered green tea, developed by Sen-no-Rikyū (1522–1591).

Ch'ing-pai:
Ch. "Bluish white" or "clear white." A term used for porcelain wares with a thin, translucent glaze with a bluish tinge. The body is usually white, translucent, and fine-grained with a sugary texture. *Ch'ing-pai* wares were widely produced in southern China, especially during the Sung dynasty.

Crackle:
(*J. kannyū; Ch. wên*) Fine surface cracks in the glaze deliberately achieved by inducing the unequal contraction of body and glaze during the cooling process after firing.

Crazing:
Network of surface cracks on ceramic glazes created inadvertently by an imbalance in the glaze mixture or perhaps by the effects of burial and age.

Densei-hin:
J. Objects (*hin*) transmitted over many generations (*densei*).

Earthenware:
Low-fired, non-vitrified, porous ceramic ware which may be glazed or unglazed.

Enamel:
An opaque glass which has been colored with a metallic oxide. Suspended in liquid solution, the enamels are applied either on the biscuit or over the glaze. Enamels are fired at comparatively low temperatures.

Fa-hua:
Ch. A term describing the Ming dynasty technique of separating areas of overglaze enamel colors with threads of clay, often in cloisonné style, or with incised lines. The enamel colors used on the porcelain or stoneware bodies are blue, purple, green, and white.

Fujiwara family:
The most important aristocratic family in Japan in the Heian period. The Fujiwara developed political power by having their daughters marry into the imperial family. This enabled members of the family to become regents and to assume other high positions in government. They were also preeminent patrons of the arts. In the early eleventh century, Fujiwara-no-Michinaga, said to be the model for Prince Genji in the *Tale of Genji* by Murasaki Shikibu (d. 1016), brought the family to the height of its influence. The Fujiwara lost their political power to the Taira in the middle of the twelfth century.

Glaze:
Finely ground minerals in liquid suspension which are applied to the surface of a ceramic body and subsequently fired, resulting in a glassy coating that

decorates the vessel and helps to seal the clay body.

Gorōdayū Shonzui:
See Shonzui.

Gosu aka-e:
J. "Red decorated ware of *gosu.*" Roughly made porcelain with spirited overglaze decoration in red, black, green, and turquoise enamels. The word *gosu* is of uncertain origin. The most convincing theory holds that the term was coined by tea masters in Japan, based on historical and literary allusions, to indicate that the ware originated at some kiln center in the South, other than at Ching-tê-chên. This was the Wu district (*gosu* in Japanese) of ancient times. The ware is known in the West as Swatow ware after the Chinese port from which it was shipped. Various sub-categories have been identified by Japanese connoisseurs. *See mochi-bana-de.*

Hideyoshi (1536–1598):
A Japanese soldier who rose from low rank to become ruler of Japan following the assassination of Oda Nobunaga. The reunification of Japan was completed during the period of his control. He encouraged many cultural developments, particularly in the fields of painting and architecture and, like Nobunaga before him, was advised by the famous tea masters Sen-no-Rikyū (1522–1591) and Furuta Oribe (1544–1615).

Jukō seiji:
J. "Jukō celadon." Indicates a particular type and color of Southern Sung dy-

nasty tea bowls made in Fukien Province. Tawny yellow to amber in tone, this rough ware was decorated with freely incised or combed designs. The tea master Murata Jukō (1423–1502) was especially fond of this ware and thus his name has become a general name for it.

Kaolin:
China clay, an essential ingredient in the manufacture of porcelain because it withstands high temperatures and fires white. Anglicized form of the Chinese word *kao-lin.*

Karamono:
J. "Chinese things." Refers to Chinese art objects, especially those imported to Japan in the Kamakura and Muromachi periods. Although it is used primarily for tea utensils, the term may also refer to paintings and other works of art.

Kinran-de:
J. A type of Ming period porcelain decorated primarily in overglaze red and gold. Later, Japanese porcelain was also decorated in this manner.

Kinuta seiji:
J. "*Kinuta* celadon." Term used to indicate a particular bright bluish celadon glaze color. Most of the pieces classified as *kinuta seiji* are Southern Sung dynasty Lung-ch'üan celadon, but sometimes examples of Southern Sung Kuan type celadon are also included. There are various stories identifying the origin of the term. One suggests that it derives from the fame of a vase named *Kinuta,* owned by Sen-no-

Rikyū; another claims that the name comes from the *kinuta* (mallet) shaped celadon vase with phoenix handles in the collection of the Bishamon-dō, Kyoto. Any celadon with a similar color was classified as *kinuta.*

Ko aka-e:
J. "Old red decorated ware." A term coined by tea men in the Edo period to distinguish earlier Ming dynasty overglaze enameled wares from the late Ming and early Ch'ing enameled wares which they termed Nanking *aka-e.*

Ko sometsuke:
J. "Old blue and white." Term identifying Chinese export porcelains produced in the late Ming dynasty. There were two general types. One was created for the Japanese tea ceremony market, according to special orders, with Japanese style decoration and shapes. The other was less specialized and included types also exported to Europe or elsewhere.

Kobori Enshū (1579–1647):
Japanese tea master who studied with Furuta Oribe. Enshū was a leader of tea taste and garden design in the early Edo period.

Matcha:
J. "Powered tea." Finely ground green tea used for *cha-no-yu.*

Mei-p'ing:
Ch. "Prunus vase." A high shouldered vase with a short neck and small mouth designed to hold a single branch of plum blossom.

Mi-se:
Ch. "Roasted rice color." A yellowish gray glaze.

Mizusashi:
J. Water jar for the tea ceremony.

Mochibana-de:
J. "*Mochi* flower type." Designation for a type of late Ming or early Ch'ing export porcelain decorated with trailed lines and dots of white slip, and usually with iron brown or cobalt blue designs as well, under a brown or blue glaze. It is a type of Swatow ware. *Mochibana* is a traditional Japanese New Year's decoration made from *mochi*, a rice paste confection, and the trailed white slip and dot designs on this ware are thought to recall the coloration and festive nature of this sweet.

Murata Jukō (1423–1502):
Sometimes called the "father of the tea ceremony," he became tea master to the Shogun Ashikaga Yoshimasa. It was from his concept of *wabi-cha*, the quiet, unassuming style of tea ceremony, that Sen-no-Rikyū developed his own ideas.

Nanking *aka-e:*
J. "Red decorated wares of Nanking." A distinctive style of ceramics created in the late Ming and early Ch'ing dynasties at non-imperial kilns at Ching-tê-chên. These wares were exported from a port near Nanking.

Nobunaga (1534–1582):
Japanese military ruler who began the reunification of Japan and the reorganization of the government after a pro-longed period of civil wars. This work was to be continued by Hideyoshi and later by the Tokugawa rulers. Nobunaga encouraged foreign trade and the *cha-no-yu* flourished under his patronage. He was served by two outstanding tea masters, Sen-no-Rikyū and Furuta Oribe.

Oda Nobunaga:
See Nobunaga.

Paste:
Term for porcelain clay bodies.

Petuntse:
China stone, a feldspathic rock that is an essential ingredient of porcelain. The term is an anglicized form of the Chinese term, *pai-tun-tzŭ.*

Porcelain:
A high-fired ceramic ware constituted of kaolin and petuntse and generally covered with a feldspathic glaze. Porcelain is hard, dense, and white. It is vitrified, resonant when struck, and usually translucent.

Porcelaneous:
Describes ceramic wares made with kaolin clay that have many but not all of the qualities requisite for true porcelain.

Sagger:
A fire clay container or box used to protect ceramic pieces in the kiln during firing. Depending on the form, saggers can facilitate loading and stacking in the kiln.

Sansai:
J. "Three colors." Direct translation of the Chinese term, *san-ts'ai.* Three-color ware was produced in Japan during the Nara period (645–794) and is called Nara *sansai* to distinguish it from Chinese three-color ware produced during the T'ang dynasty (618–906).

San-ts'ai:
Ch. "Three colors." Polychrome glaze decoration, not necessarily limited to three colors. In the T'ang dynasty *san-ts'ai* was a popular method of decorating earthenware. The glazes commonly used were amber, yellow, green, and blue, often applied in a manner that produced dappled or streaked effects. In the Ming and Ch'ing dynasties, *san-ts'ai* decoration was added to stoneware using yellow, green, aubergine, blue, and white enamels. *Fa-hua* is a type of Ming dynasty three-color ware. *See fa-hua, sansai.*

Sencha:
J. "Infused tea." Name for a type of tea ceremony introduced from China in the seventeenth century and developed in Japan during the Edo period (1615–1868). Leaf tea steeped in hot water is used rather than the whipped powdered tea of the *cha-no-yu.*

Sen-no-Rikyū (1522–1591):
The preeminent tea master of Japan. He established criteria for *cha-no-yu* which have influenced all tea masters and connoisseurs since his time. Rikyū served two military rulers, Nobunaga and Hideyoshi.

Seto:

Site of one of the traditional "Six Old Kilns" of medieval Japan, Seto was located in Owari Province (present Aichi Prefecture). The oldest ceramic center in Japan, Seto is the place where the first glazed stoneware was produced, during the Kamakura period (1185–1333). The shapes and decoration of Sung celadons were imitated at this center.

Shichikan seiji:

J. "*Shichikan* celadon." Term generally used to encompass all celadons dating from the Ming to the early Ch'ing dynasties that are not described as either *kinuta* or *Tenryū-ji* celadon. The glaze is described as greener than *kinuta* and more glassy than *Tenryū-ji*. Like other celadons, *shichikan* celadon was probably produced at the Lung-ch'üan kilns. The term is said to indicate either that seven (J. *shichi*) visiting Chinese officials (J. *kan*) first introduced this type of ware to Japan, or that such celadons were supplied by a Chinese official of the seventh rank.

Shonzui:

A name in an inscription found on a special type of Chinese blue and white ware of late Ming to early Ch'ing dynasty date. In its fullest form, the inscription reads in Japanese *Gorōdayū Go Shonzui zō* (Ch. *Wu liang t'ai fu wu hsiang jui tsao*) and can be translated "made by Gorōdayū Go Shonzui." Various interpretations have been advanced in Japan to explain this inscription. No longer accepted are the traditional theories that Gorōdayū was a Japanese who went to China in the six-

teenth century and learned the techniques of porcelain making from a Chinese named Shonzui (or at a place called Shonzui); or, that in China Gorōdayū adopted the art name Go Shonzui (Shonzui of Go) and made, or supervised, the making of some of this ware. A current explanation is that *Shonzui* ware was a special order tea ceremony ware created at private kilns at Ching-tê-chên for export to Japan. *See Shonzui-de, aka-e Shonzui.*

Shonzui-de:

J. "*Shonzui* style." Term for a particular style of Chinese export porcelain produced from the late Ming to the early Ch'ing dynasty and created on special order expressly for the Japanese market. Spectacular examples are characterized by a finely executed and varied painting style in brilliant underglaze blue on a bright white body, often featuring circular or other geometric designs alternating with passages of repeated patterns.

Slip:

Liquid clay used as an undercoat for glazes and a base for applied decoration.

Sometsuke:

J. General term for porcelain decorated with underglaze cobalt blue. Such wares had been produced in China since the Yüan dynasty, but in Japan production did not begin until the early seventeenth century or possibly somewhat earlier. This term is sometimes used for blue and white porcelain made in the late Ming dynasty for export to Japan. *See ko sometsuke.*

Stoneware:

A high-fired, vitrified ceramic ware. Usually glazed, it is dense, hard, and not translucent. The color of the body varies.

Sutra mounds:

The concept of erecting sutra mounds was introduced to Japan in the middle Heian period by the famous pilgrim priest Ennin (Jikaku Daishi) upon his return from China. During the eleventh and twelfth centuries, a time of considerable unrest in Japan, many people felt that Buddhism was entering a cycle of decline (J. *Mappō*) and that the end of the world was at hand. In order to insure the preservation of the Law it became a common practice to bury copies of sutras. They were placed in containers of ceramic, wood, metal, or stone and buried along with other objects beneath a stone monument.

Taira family:

Samurai family which contended with the Fujiwara and their supporters, the Minamoto, for power at court during the late Heian period. United to the imperial family by marriage, as the Fujiwara had been before them, the Taira enjoyed an era of glory under the leadership of Kiyomori in the second half of the twelfth century until they were decisively defeated by the Minamoto in 1185.

Takeno Jōō (1502–1555):

A prominent tea master to whom are attributed many developments in *cha-no-yu*, especially innovations in the design of tea implements.

Temmoku:
J. Tea bowls with a black iron glaze used in the tea ceremony. *Temmoku* is the Japanese pronunciation of T'ien Mu, the name of a mountain temple site in Chekiang Province. During the Kamakura period, Japanese Zen monks visiting the area found a particular type of tea bowl in use. Subsequently they introduced the bowls and the term *temmoku* to Japan. The original *temmoku* type were Chien ware bowls. In more recent times similar bowls from various other kilns have been designated as *temmoku* types. The ware was emulated at kilns in Japan as well.

Tenryū-ji seiji:
J. "*Tenryū-ji* celadon." Describes a particular olive green glaze on Lungch'üan celadon, usually of Ming dynasty date. During the Muromachi period, the Tenryū-ji in Kyoto received a franchise to dispatch ships for trade with China, and the term derives from the color of celadon wares imported on these Tenryū-ji ships.

Three-color ware:
See sansai, san-ts'ai.

Toyotomi Hideyoshi:
See Hideyoshi.

Wabi:
J. An aesthetic term meaning quiet, solitary, and unassuming. Used in relation to ceramics of the *cha-no-yu.*

Wu-ts'ai:
Ch. "Five colors." Porcelains painted in underglaze blue and overglaze red, green, yellow, and purple enamels. In Japan such wares are generally termed *aka-e.* The Japanese have made various distinctions for Chinese overglaze decorated wares. *See ko aka-e,* Nanking *aka-e, gosu aka-e.*

Yao:
Ch. "Ware." The basic meaning is "kiln," but the word is generally translated as "ware."

Ying-ch'ing:
Ch. "Shadow blue." Southern Sung porcelain ware with a slight bluish hue. The term was used by Peking dealers in the early twentieth century for *ch'ing-pai* ware. Today *ch'ing-pai* is more commonly used. *See ch'ing-pai.*

Yoshimasa (1435–1490):
Eighth shogun of the Ashikaga line, famous for building the Silver Pavilion in Kyoto. Like Yoshimitsu, he was a great aesthete and collector. Yoshimasa is believed to have established the precedent for using a specially designed room for the tea ceremony when he built the Tōgu-dō, a building near the Silver Pavilion.

Yoshimitsu (1358–1408):
Third shogun of the Ashikaga line, he promoted trade with Ming China. His interest in Chinese art and ceramics for the tea ceremony is believed to have encouraged the emulation of Sung dynasty ceramics at Japanese kilns. He is probably best remembered for his patronage of the Nō drama and for building the villa which became the Kinkaku-ji (Golden Pavilion).

Selected Bibliography

1. *Ataka Korekushon Meitō Ten: Kōrai, Richō* [Exhibit of Masterpieces of the Ataka Collections: Koryo and Yi Dynasties]. Tokyo: Nihon Keizai Shimbunsha, 1976.

2. AYERS, JOHN. *The Baur Collection, Geneva: Chinese Ceramics.* Vol. 2. Geneva: Collections Baur, 1969.

3. *The Ceramic Art of China.* London: Victoria and Albert Museum, 1971.

4. *Ceramic Art of Japan: One Hundred Masterpieces from Japanese Collections.* Seattle: Seattle Art Museum, 1972.

5. CHIH PI-CHÊ, and HUNG LIN. "Investigation of the Ting Ware Kiln-Site at Chien-Tz'u Ts'un, Hopei." *K'aogu*, (1965) no. 8, pp. 394–412. (Victoria and Albert Museum in association with The Oriental Ceramic Society, Chinese Translation No. 4).

6. *Chinese Blue and White Porcelain and Related Underglaze Red.* Introduction by Sir John Addis. Hong Kong: The Oriental Society of Hong Kong, 1975.

7. *Chinese Ceramics from the Prehistoric Period through Ch'ien Lung.* Los Angeles: Los Angeles County Museum of Art, 1952.

8. *Chūgoku Sō Gen Bijutsu Ten* [Chinese Arts of the Sung and Yüan Periods]. Tokyo: Tokyo National Museum, 1961.

9. *Chūgoku Tōji Meihin Ten: Ataka Korekushon* [Masterpieces of Old Chinese Ceramics from the Ataka Collection]. Tokyo: Nihon Keizai Shimbunsha, 1975.

10. FENG HSIEN-MING. "Important Finds of Ancient Chinese Ceramics Since 1949." *Wen wu*, (1965) no. 9, pp. 26–56. (Victoria and Albert Museum in association with The Oriental Ceramic Society, Chinese Translation No. 1).

11. _____. "Report on the Investigation of Kiln-Sites of Ju-Type Ware and Chün Ware in Lin-Ju Hsien, Honan." *Wen wu*, (1964) no. 8, pp. 15–26. (Victoria and Albert Museum in association with The Oriental Ceramic Society, Chinese Translation No. 3).

12. FUJIOKA, RYŌICHI. *Min no Aka-e* [Overglaze Decorated Ware of the Ming Dynasty]. *Tōji Taikei* [Outline of Ceramics], vol. 43. Tokyo: Heibonsha, 1972.

13. _____. *Min no Sometsuke* [Blue and White Wares of the Ming Dynasty]. *Tōji Taikei* [Outline of Ceramics], vol. 42. Tokyo: Heibonsha, 1975.

14. GARNER, SIR HARRY M. *Oriental Blue and White.* New York: Praeger, 1970.

15. GOMPERTZ, G. ST. G. M. *Celadon Wares.* London: Faber and Faber, 1968.

16. _____. *Chinese Celadon Wares.* New York: Pitman, 1957.

17. GRAY, BASIL. *Early Chinese Pottery and Porcelain.* New York: Pitman, n.d.

18. HASEBE, GAKUJI, ed. *Chūgoku Bijutsu* [Chinese Art in Western Collections]. Vol. 5. *Ceramics.* Tokyo: Kodansha, 1973.

19. _____. *Chūgoku Ko Tōji* [Ancient Chinese Ceramics]. Tokyo: Mainichi Shimbunsha, 1971.

20. _____. "Connections Between the Ceramics of China and the Ancient and Medieval Ceramics of Japan." In *International Symposium on Japanese Ceramics.* Seattle: Seattle Art Museum, 1973.

21. _____. *Shōrai Bijutsu* [Ancient Imported Art]. *Genshoku Nihon no Bijutsu* [Japanese Art Illustrated in Color], vol. 30. Tokyo: Shogakkan, 1972.

22. _____ and SATO, MASAHIKO. *Zui—Tō* [Sui—T'ang]. *Sekai Tōji Zenshū* [Collection of World Ceramics], vol. 11. Tokyo: Shogakkan, 1976.

23. HAYASHIYA, SEIZO and HASEBE, GAKUJI. *Chinese Ceramics.* Tokyo: Charles E. Tuttle, 1966.

24. HONEY, WILLIAM BOWYER. *The Ceramic Art of China and Other Countries of the Far East.* London: Faber and Faber and the Hyperion Press, 1945.

25. JENYNS, SOAME. *Japanese Porcelain.* New York: Praeger, 1965.

26. _____. *Ming Pottery and Porcelain.* London: Faber and Faber, 1953.

27. *Jusshūnen Kinen Zuroku* [Special Exhibition Commemorating the Tenth Anniversary of the Idemitsu Collection]. Tokyo: Idemitsu Art Gallery, 1976.

28. *Kisō Hirota Matsushige Korekushon Mokuroku* [Catalogue of the Collection Donated by Mr. Matsushige Hirota]. Tokyo: Tokyo National Museum, 1973.

29. KOYAMA, FUJIO, ed. *Chūgoku Meitō Hyakusen Ten* [Exhibition of One Hundred Masterpieces of Chinese Ceramics]. Tokyo: Nihon Keizai Shimbunsha, 1960.

30. ———. *Chūgoku Tōji* [Chinese Ceramics]. Vol. 1. Tokyo: Heibonsha, 1970.

31. ———, ed. *Japanese Ceramics from Ancient to Modern Times*. Oakland, California: Oakland Art Museum, 1961.

32. ——— et al., eds. *Sekai Tōji Zenshū* [Collection of World Ceramics]. Vols. 7, 9–12. Tokyo: Zauho Press and Kawade Shobo, 1955–56.

33. ———. *Temmoku. Tōji Taikei* [Outline of Ceramics], vol. 38. Tokyo: Heibonsha, 1974.

34. ——— and FIGGESS, JOHN. *Two Thousand Years of Oriental Ceramics*. New York: Abrams, 1961.

35. ———. "The Yüeh-Chou Yao Celadon Excavated in Japan." Translated by Dr. Jiro Harada. *Artibus Asiae*, vol. 14, pp. 26–42.

36. *Kusado Sengen-chō Iseki* [Report on the Excavations of the Site of Kusado Sengen-chō]. Nos. 11–14. Hiroshima: Hiroshima Prefecture Board of Education, 1974.

37. *Kusado Sengen-chō Iseki* [Report on the Site of Kusado Sengen-chō]. Hiroshima: Hiroshima Prefectural Cultural Research Committee, 1975.

38. LEFEBVRE D'ARGENCÉ, RENÉ-YVON. *Chinese Ceramics in the Avery Brundage Collection*. San Francisco: The de Young Museum Society, 1967.

39. MAYUYAMA, JUNKICHI, ed. *Chinese Ceramics in the West: A Compendium of Chinese Ceramic Masterpieces in European and American Collections*. Tokyo: Mayuyama, 1960.

40. MEDLEY, MARGARET. *The Chinese Potter*. New York: Scribner's, 1976.

41. ———. *Yüan Porcelain and Stoneware*. New York: Pitman, 1974.

42. MINO YUTAKA. "Brief Survey of Early Chinese Glazed Wares." *Artibus Asiae*, vol. 37, pp. 39–52.

43. *Min-Shin Ten* [Chinese Art of the Ming and Ch'ing Dynasties]. Tokyo: Tokyo National Museum, 1963.

44. NEAVE-HILL, W. B. R. *Chinese Ceramics*. New York: St. Martin's Press, 1975.

45. *Nezu Bijutsu-kan Meihin Mokuroku* [Selected Masterpieces from the Collection of the Nezu Art Museum]. Tokyo: Nezu Art Museum, 1968.

46. *Nihon Kōko Ten* [Japanese Archaeology: Exhibition Documenting Its Development during the Past 25 years]. Tokyo: Tokyo National Museum, 1969.

47. *Nihon Shutsudo no Chūgoku Tōji* [Chinese Ceramics Excavated in Japan]. Tokyo: Tokyo National Museum, 1975.

48. PLUMER, JAMES MARSHALL. *Temmoku: A Study of the Wares of Chien*. Edited and arranged by Caroline I. Plumer. Tokyo: Idemitsu Art Gallery, 1972.

49. *Porcelain of the National Palace Museum*. Vols. 1–3. Hong Kong: Cafa, 1961–1969.

50. PRODAN, MARIO. *The Art of the T'ang Potter*. New York: Viking Press, 1961.

51. REISCHAUER, EDWIN O. and FAIRBANK, JOHN K. *East Asia: The Great Tradition*. Boston: Houghton Mifflin, 1960.

52. SAITO, KIKUTARŌ. *Gosu Aka-e—Nankin Aka-e* [Swatow Ware—Nanking Colored Ware]. *Tōji Taikei* [Outline of Ceramics], vol. 45. Tokyo: Heibonsha, 1976.

53. ———. *Ko Sometsuke—Shonzui* [Old Blue and White—Shonzui]. *Tōji Taikei* [Outline of Ceramics], vol. 44. Tokyo: Heibonsha, 1972.

54. SANSOM, SIR GEORGE. *A History of Japan: To 1334*. Stanford: Stanford University Press, 1958.

55. ———. *A History of Japan: 1334–1615*. Stanford: Stanford University Press, 1961.

56. Tokyo National Museum. *Proceedings*. Vol. 3. Tokyo, 1967.

57. *Tō Sō Meitō Ten* [Masterpieces of T'ang and Sung Ceramics]. Tokyo: Otzuka Kōgeisha, 1964.

58. *Tōyō Bijutsu Ten* [Exhibition of Eastern Art]. Tokyo: Tokyo National Museum, 1968.

59. *Tōyō Ko Tōji* [Illustrated Catalogue of Old Oriental Ceramics Donated by Mr. Yokogawa]. Tokyo: Tokyo National Museum, 1953.

60. *Tōyō no Tōji: Tōyō Tōji Ten Kinen Zuroku* [Commemorative Catalogue of the Exhibition of Far Eastern Ceramics]. Tokyo: Tokyo National Museum, 1971.

61. *Tōyō Tōji Meihin Ten: Ataka Korekushon* [Exhibition of Selected Masterpieces of Old Chinese and Korean Ceramics from the Ataka Collection]. Tokyo: Nihon Keizai Shimbunsha, 1970.

62. *Tōyō Tōji Taikan* [Oriental Ceramics: World's Great Collections]. Vol. 1. Tokyo: Kodansha, 1976.

63. *Tōyō Tōji Ten* [Far Eastern Ceramics]. Tokyo: Tokyo National Museum, 1970.

64. *Treasures of Ancient Oriental Art: Special Exhibition in Commemoration of the Tokyo Olympics.* Tokyo: Tokyo National Museum, 1964.

65. VALENSTEIN, SUZANNE G. *A Handbook of Chinese Ceramics.* New York: The Metropolitan Museum of Art, 1975.

66. YABE, YOSHIAKI. *Gen no Sometsuke* [Yüan Dynasty Blue and White]. *Tōji Taikei* [Outline of Ceramics], vol. 4. Tokyo: Heibonsha, 1974.

Journals

67. *Archives of Asian Art* (formerly *Archives of the Chinese Art Society of America*). New York, 1945—

68. *Artibus Asiae.* Ascona, 1926—

69. *K'aogu* (Chinese Archaeological Reports). Peking, 1955—

70. *Oriental Art.* Oxford, 1955—

71. *Transactions of The Oriental Ceramic Society.* London, 1921—

72. *Wen wu* (Journal of Chinese Culture). Peking, 1950—

73. *Yamato Bunka* (Journal of Japanese Culture). Nara, 1951—

CHINESE CERAMICS FROM JAPANESE COLLECTIONS
is the catalogue of an exhibition shown in Asia House Gallery
in the spring of 1977 as an activity of The Asia Society
to further greater understanding between the peoples of
the United States and Asia.

Design by Joseph Bourke Del Valle
Composition by A. Colish, Inc., Mount Vernon, N. Y.
Printed by S. D. Scott Printing Company, Inc., New York, N. Y.
Bound by Sendor Bindery, New York, N. Y.